Calligraphy Techniques

John Lancaster

B T Batsford Ltd London

This book is dedicated to Edward Ackroyd, my art master at school, who introduced me to the 'creative' quill, and to Thomas W Swindlehurst who taught me how to cut a feather and helped me to become a little more skilful in formal penmanship. Their tuition and encouragement is appreciated.

© John Lancaster 1986
First published 1986
Reprinted in paperback 1992

ISBN 0 7134 4370 7

Typeset by Servis Filmsetting Ltd, Manchester
and printed in Great Britain by
Courier International Ltd
East Kilbride, Scotland
for the publishers
B.T. Batsford Ltd
4 Fitzhardinge Street
London W1H 0AH

1003469397

CONTENTS

ACKNOWLEDGMENT 7

INTRODUCTION 9

1 STARTING OFF 11
 Basic materials and equipment for the calligrapher 11
 The pen 12

2 CALLIGRAPHIC IMAGERY 14
 Simple mark making 14
 Some ideas as starting points 18

3 MOVING ON 21
 The medieval scribe 21
 Adopting a good writing position 28
 The work surface 28

4 PEN-MADE PATTERNS 31

5 A FORMAL ROUND HAND 36
 Formal calligraphy 36
 The foundation hand 38
 How to do a round hand script 43
 Introducing some informality 52

6 ITALIC SCRIPT 62
 Italic handwriting 62

7 DESIGN AND LAYOUT 82
 1 The book 82
 2 The illuminated address 91
 3 Poetry 92
 4 General layout 93
 5 Letter writing 100

8 EXPERIMENTAL APPROACHES 106
 Some starting points 106

9 HISTORICAL CHART 128

BIBLIOGRAPHY 138
PRINCIPAL CALLIGRAPHY SOCIETIES 139
SUPPLIERS 141
INDEX 143

ACKNOWLEDGMENT

My grateful thanks must go to a number of people for their help with illustrative material used in this book. Amongst them are:

Dr Helen Austin, art instructor and art gallery curator, and *Wayne R Brown* (photographer) both at John Calhoun Community State College, Decator, Alabama, USA.

Sue Cavendish, Secretary of the Society of Scribes and Illuminators; *John Davie,* photographer, artist and Head of Creative Arts, College of St Paul and St Mary, Cheltenham; *Liz O'Sullivan* (designer); *Ann Hechle, E John Milton-Smith, John Poole, Jean Larcher, Malcolm Drake, David Howells* and *Lilly Lee* as well as other calligraphers, designers and illuminators whose work appears in this book; *Timothy Donaldson; Colonel F Patrick Cook; John Storrs;* my wife, *Janet,* for her patience; and finally to *Thelma Nye,* my editor, for her encouragement.

Cheltenham 1986

Caption to illustration overleaf
Calligraphy by Jean Larcher

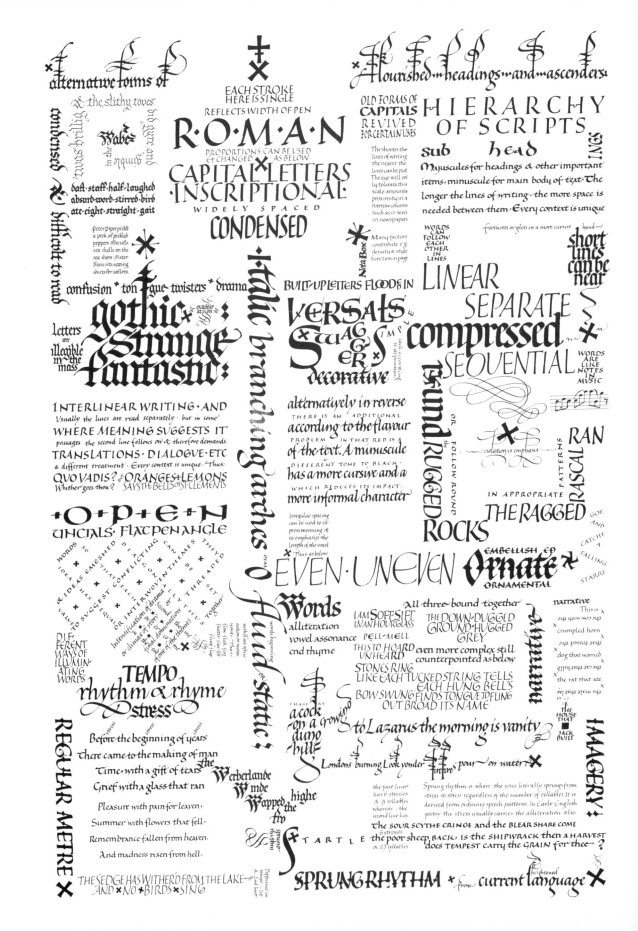

INTRODUCTION

This book is concerned with creative penmanship, an aspect of the visual arts embracing manipulative skills, love for beautiful writing and inventiveness on the part of the calligrapher. Its main focus is upon calligraphy techniques with the square-ended (or broad-edged) pen, materials, and layout, and also upon personal inventiveness which, after all, is a fundamental element in this long-established craft. My hope is that amateur scribes and students interested in lettering, whether as a main or supporting aspect in their art and design studies, will acquire confidence, some basic skills and knowledge of the 'creative pen'.

It is not my intention to dictate a style, although the main thrust of the book is towards a *Round Hand* lettering form which Edward Johnston borrowed from tenth-century manuscripts. Any style is personal. In dealing with the basics of round hand I introduce the reader to a fundamental concept based upon the circle – an idea which E John Milton-Smith, the Yorkshire calligrapher and illuminator, pointed out – for this epitomises the style. The simple mechanics involved should, I believe, make it easier for the non-professional to learn this writing hand comparatively easily and quickly.

As well as looking at traditionally-conceived design and layout I ask the reader to consider diverging into more adventurous creativity. I set out a few ideas, which are based upon a series of simple stages that are illustrated with examples of my own work, which should help the reader to build-up the final image so that he or she may appreciate the designing process more clearly and also be in a better position to pursue individual artistry.

This stage-by-stage process is a way of working with the pen – which I invariably do in a free-hand manner – and is a personal one resulting from my dual role as a *calligrapher* and *abstract painter*. Perhaps this is where I differ from the majority of present-day scribes who tend to be narrowly channelled in a traditional mould, for having experimented vigorously with tachism, landscape and hard-edged optical painting on both a large and minute scale, I sometimes feel I am a 'calligraphic painter'.

I make no apologies for I enjoy my particular brand of artistry. This for me, is the age-old secret behind all aspects of the visual and plastic arts although there are times when the natural ease of my graphicacy embraces a great deal of struggle and tension.

From Letter sampler by Ann Hechle

9

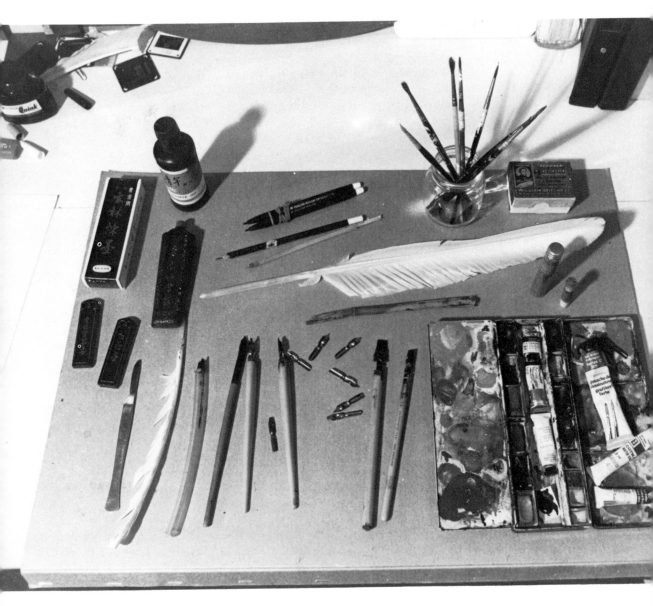

1
STARTING OFF

You cannot expect to make a good start without acquiring what I call a *calligraphic* or *scribe's kit*, so I have prepared an alphabetically-arranged list of materials and equipment. These are essential for anyone who seriously contemplates pursuing this craft at any length. Feeble efforts are no use. You must be prepared to think about the task ahead, to get thoroughly organised and to plan your course of action.

In the list I have indicated the essential basic items with an asterisk (*). These are absolutely vital, others may be acquired as you go on.

BASIC MATERIALS AND EQUIPMENT FOR THE CALLIGRAPHER

Board* A drawing board 60 cm × 45 cm is a convenient size.

Brushes Three or four sable-type brushes. Sizes 2, 4, 5 and 6 will be adequate at the start.

Container A strong cardboard box (shoe box) or plastic deep freeze box is handy for storing pens, nibs, inks, etc.

Cutting slab You might need a piece of glass, white formica or celluloid for use in cutting quills.

Desk or table* I use a home-made table constructed from a length of shelving which I place across three smallish filing cabinets. It gives me an expansive working surface at a height of 80 cm from the floor.

Easel (table-top type) It is possible to hinge a drawing board to the front edge of your work-top, allowing it simply to rest upon a pile of heavy books. The purpose is, of course, to provide you with a sloping surface at a comfortable writing angle.
– I use a *Dart* table easel (*Stablemate*). It is made of sturdy metal tubing painted white and has five positions at which the board may be raked.

Erasers Both soft (putty rubber), kneaded and harder rubber erasers will be invaluable.

Inks* Good quality fountain pen inks are excellent for practice work.
– Non-Waterproof Chinese 'Stick' ink (black) rubbed down with a little pure water, must be used for all finished, high-quality work. Never use black waterproof drawing inks as these congeal and clog the pen.

1 A selection of calligraphy tools and materials. These include an uncut swan's flight feather, various pens (one cut from a goose quill, one cut from a piece of plastic tubing, dip pens, a reed pen and poster pens), a box of artist's watercolours, Chinese non-waterproof stick ink, bottled inks, brushes, a scalpel, and two small glass containers of fine levigated powder colours (illuminating pigments)

Light Lighting should come from the left-hand side (that is if you are right-handed) and an angle-poise lamp (or similar) will give you 'directed' illumination.

Pencils* Two or three pencils are needed for line ruling, etc, and I recommend H, 2H and 3H.

Paper* Ordinary typing paper or cartridge paper is fine for experimental work or on which to practise.

– More expensive, smooth handmade papers should be employed for quality work.

Pens A range of pens is obviously desirable at some stage, but for a start I suggest that a small number will suffice.

– Fibre-tipped *Edding* 1255 calligraphy pens and *Berol* 'Italic Pens' Q 51

– Dip pens (penholder with metal nibs and reservoirs)

 William Mitchell square-ended round hand nibs

 Brass reservoirs

 Pen holders

– Heintze and Blanckert pens

– Boxall pens for larger work

– Coit pens (toothed nibs)

– Quills (the best are flight feathers – which are the leading feathers on the bird's wings – from swans, turkeys and geese)

– Special calligraphy pens (various makers)

– Ball-point pens.

Penknife* A strong, sharp knife is needed if you intend to cut quills or reeds and, indeed, for scratching out mistakes on the paper or vellum ground. A surgical scalpel is the best for this type of work.

Rags or paper towels A supply of clean rags is helpful for cleaning pens, nibs, brushes, etc, although I grab hold of any toilet paper or kitchen paper which is close to hand.

Ruler* Choose a strong ruler (30 cm wooden or metal). I have a 45 cm plastic *Vetran* ruler which I find helpful because it is transparent and has a number of black lines on the underside.

Sharpening stone A fine carborundum stone can be a useful aid for sharpening metal nibs and penknives.

T square A smallish T square (mine has a 60cm blade) will give you accurately drawn guide lines.

THE PEN

I shall assume that you have used metal nibs in a pen holder, and that the use of the felt-tipped or fibre-tipped pen is understood, but will say just a few words about the *quill*.

As already noted the best feathers come from the swan, turkey or goose. These are strong and lend themselves well to being cut into broad-edged pens. The drawing of a bird's wing makes it clear that *primary feathers* are

the best for the purpose of the scribe. Indeed, the best of all are the first two or three from the leading edge of the wing.

When the feathers have been selected they must be left to mature. This takes 18 months or so; a long process which some calligraphers avoid by heating the feathers in hot sand so that they are firm or brittle rather than soft and flexible. The shaft of a quill is cut to a suitable pen length with a sharp penknife and the 'feathered' parts (the barbs) are removed. The pen is now cut so that it has a broad, finely-chiselled writing point.

For large script writing a reed or bamboo pen is excellent and, like a quill, it will last for years. It simply requires to be re-cut from time to time.

Contrasting *thick* and *thin* strokes are made by the broad-edged pen, which should be held between the thumb and the forefinger, and be supported by the middle finger. It should point over the shoulder and a wrist action will supply the necessary movement.

2 *The quill pen*

1 A primary or 'flight' feather from the leading edge — characterised by 'STRENGTH'!

2 The shaft cut to pen length & stripped of the barbs

3 Shape of pen [quill] when cut

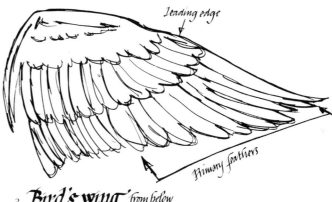

leading edge

Primary feathers

3 *Bird's wing* from below

2

CALLIGRAPHIC IMAGERY

Calligraphy may be viewed as 'elegant penmanship', which can be off-putting to the amateur who immediately feels that it must be much too sophisticated a craft for him. I like to take the view that it is 'the wholeness of written forms' and that it should be seen to embrace all graphic imagery, whether this is made with a pen, a brush, a piece of stick or card, or even with the fingers. The preciousness given to it by many calligraphers who have sought through the ages to attain perfection in the written image, has tended, therefore, to raise beautiful writing to the realms of art which, in itself, is an excellent thing. Indeed, as a calligrapher myself, I cannot but ascribe to this, yet I fail to see why it should be offputting to the non-professional, particularly as lettering of all kinds plays such a vital role in our everyday lives.

If you are a beginner do not be discouraged. I contend that you should take an *experimental* approach and be yourself. Enjoy what I refer to as 'mark making' with an implement and a medium – ink, paint or dye.

The aim should be to forget technique and to produce graphic images which give enjoyment to both yourself and to the observer. In doing this you will have 'instant success'. It is important that a great many images be made, especially as these can result from a natural and rhythmical spontaneity, then as confidence is acquired and skills are developed you can be assured that your expertise will grow.

SIMPLE MARK MAKING

Most people – young and old alike – tend to be somewhat inhibited in expressing themselves with materials. Yet it is easy to produce marks of all kinds by *dragging* a drawing implement over the surface of a sheet of paper, canvas or board, and by *dropping* inks or paints or even *throwing* these onto a surface, as taschist painters did some years ago.

You could be excused for asking 'Is this calligraphy?' I maintain that, in essence, it is. I also claim that drawing is a form of calligraphy and, conversely, that calligraphy is a form of drawing. After all, when we write with a pencil, ball-point pen, a felt-tipped pen, a brush or quill we are actually involved in the drawing process. We are draughtsmen. The

4 *Facing page:* Marks made with the tip of a goose feather and black ink

5 Dynamic images produced with scrap paper and ink

14

6 *Above left:* Juxtaposed felt-tipped images

7 *Top:* Inter-relating forms with felt-tipped pen

8 Calligraphic forms produced in a 'tachist' manner

9 *Left:* Drawing of rock formations made with a stick and black ink

16

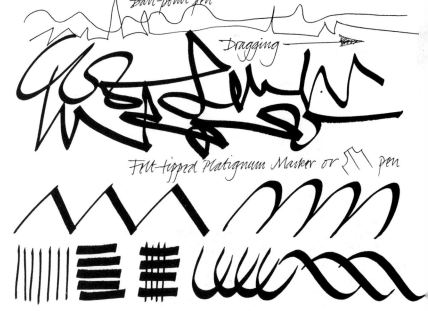

12 Cover design by John Lancaster for prospectus incorporating calligraphic imagery, made with pieces of card and ink, and type faces

10 *Top:* Rapidly drawn landscape images

11 Marks with ball-point and felt-tipped pens

calligrapher, then, is a draughtsman. He draws as he produces his letter forms with a quill on vellum. The difference is that because he is highly talented, and has mastered the skills which are so necessary in making beautiful letters so that he can reproduce these with a natural ease, his craft is raised to the realms of technical excellence which, of course, will be your goal if you persevere.

I propose that in developing your own calligraphic techniques, you should attempt to dismiss all thoughts of letter making from your mind at the initial stage. Simply enjoy doing some mark making. Tell yourself that everything you do 'is right'. Throw caution to the winds, and work with gusto.

All you require to begin are a few cheap materials. Your working surfaces may be old newspapers or wrapping papers spread out on a table top, the garage floor, the lawn or patio, depending on whether you wish to work on a large or small scale. There are times when I work in the kitchen. At others I have spread paper all over a bedroom floor, or I have pinned paper or card on a wall so that I could have a strong feeling of freedom and flexibility.

Many people, having seen pictures of medieval scribes at work at a desk, feel that they must emulate this. They sit in a rigid position, therefore, getting cramp in their legs, a stiffness in their arms, and acquire a frustrating attitude which overwhelms any pleasure they hope to gain. What happens? They simply give up.

SOME IDEAS AS STARTING POINTS

Take some sheets of paper. You could start on some left-over rolls of wallpaper. Some sheets of wrapping paper might be equally useful. If you want to try using very large surfaces, tape some of these sheets together so that you can then make excitingly gigantic images.

Mix up some black ink or strong paint (left-over emulsions or acrylics are excellent) in suitable containers; take a piece of rag and soak it in this pigment. It is now an easy matter to produce large, bold marks by simply holding your arm stiff and working from the shoulder. Squeeze the rag so that the pigment runs on to the paper and the resultant imagery may be 50 cm to 76 cm long. Simply get involved as a vigorous draughtsman.

Here are a few basic suggestions to help you:

SHEET 1 Make at last ten *vertical lines* of varying length (38 cm to 76 cm) and strength. Some may be heavy and others delicate.

SHEET 2 Do the same again but this time produce *sloping lines*.

SHEET 3 Cover this sheet with short and long *horizontal lines*. Some of these could actually go from edge to edge.

SPREAD 4 You should soon discover that you are able to make some extremely fine lines simply by using your finger nails as pens. All you do is to squeeze the rag (or it could be a sponge) gently so that the pigment runs down your fingers and then your nails

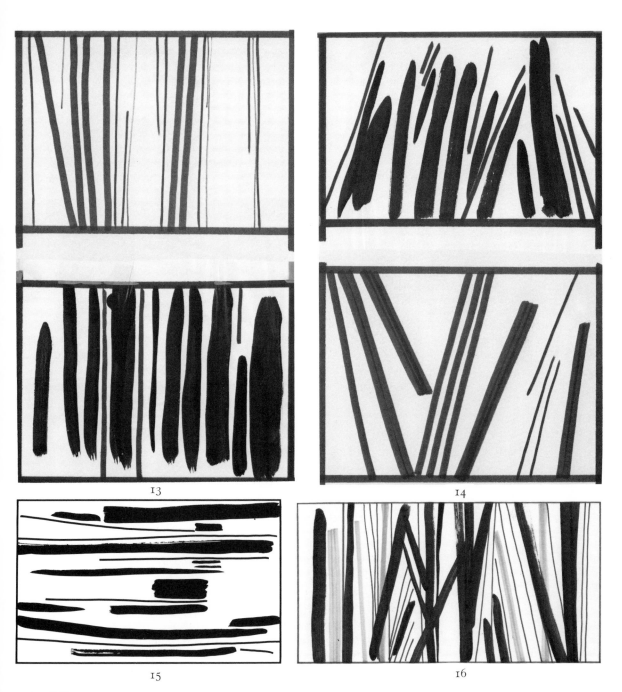

13 14

15 16

13 to 18 EXAMPLES OF LINE
EXERCISES
13 Vertical lines
Top Felt-tipped pen *Bottom* Brush and paint
14 Sloping lines
Top Made with a brush *Bottom* Produced with a felt-
tipped pen

15 Horizontal lines made with a brush
16 These vertical and sloping lines are a mixture of
felt-tipped pen and brush

17 Circular forms, quickly made with brush and felt-tipped pen

18 Combined images with brush

(one, two, three or more) and on to the work surface.
(Some people may feel that an approach to drawing such as
this is messy. So it is. But I find it both exciting and
stimulating. It certainly gives me a tremendous confidence in
graphicacy and it is easy to wash surplus pigment from my
hands. I often wear a rubber glove.)

SHEET 5 Experiment by combining vertical and sloping lines.
SHEET 6 Produce some large circular forms on this sheet.
SHEET 7 Now try combining some circular images and straight lines side
 by side; overlapping; and then in a variety of combinations.

3
MOVING ON

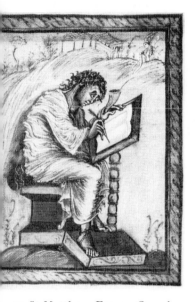

Now that you have undertaken a number of bold, experimental approaches to calligraphic image making it is time to consider more serious aspects concerned with the art of writing. In doing so you are obviously depending upon traditional techniques but as these result from natural human actions they are just as relevant now as they were in Ancient Egypt, Greece, Rome or medieval Europe.

The human body consists of a basic yet sophisticated and technically advanced skeletal frame which supports it from within. This frame is, as we all know, jointed in such a way that it facilitates the performance of many and varied everyday actions. One such action is that of writing, which is really the art of producing beautifully conceived calligraphic images with pens, brushes or other suitable implements. This can be performed in either a standing or a seated position. The standing position is a useful one to adopt for large-scale work, but is seldom used by the scribe who prefers to be seated so that long periods can be sustained.

19 St Matthew. From a Gospel manuscript *c* AD 800. Schatzkammer Vienna

THE MEDIEVAL SCRIBE

In the Middle Ages when a great deal of writing was undertaken in religious communities – in abbeys, monasteries, cathedrals and even churches – monks, who were skilled in using quill pens, worked ceaselessly in transcribing the scriptures, writing and illuminating prayer books and bestiaries. Sometimes they would work alone, sitting at specially-made desks with sloping lids. At other times they worked alongside a number of their fellow monks in a scriptorium – or even, as at Gloucester, in a covered cloister – an improvised *writing studio or workshop*. They would, therefore, do their individual writing perhaps in a small cell, or would listen in a group as a fellow monk read out sections from religious works, dictating to them what they should write.

Although a religious house might have a writing style of its own, such as the one at Winchester which gave its name to what we know as *Winchester script*, individuals would develop their own styles. Some, indeed, would come from other places, bringing with them different writing hands.

20 From *French Decorative Arts.*
J Paul Getty Museum, Santa
Monica, California

21 The author using a dip-pen
(William Mitchell metal nib
with brass reservoir) on a sloping
board which rests in his lap. A
'test' sheet protects the writing
surface

22 The author producing letter-
patterns with a quill. The
sloping writing surface is
actually on the table-top easel

Imagine the scene in a scriptorium. It might be a rather drafty, stone-flagged room – possibly with a carpet of straw, with tapers flickering if natural lighting was dim. A fire might be burning in a large grate or a number of braziers would be placed strategically around the room to provide heat. Monks in long, heavy woollen robes, with hoods pulled over their heads, would be sitting at their work. Those near to the fire or braziers might be hot, others further away might be cold. The sounds of coughing, sneezing and the scratching of quills on vellum would punctuate the concentrated industry. At times a monk might ask the reader to repeat a sentence while another, feeling bored or tired, would leave the room to take a walk through the cloisters or to re-cut an awkward pen.

Such a naturally busy scene was common in the medieval period, but it must be remembered that this was only one of the many activities in which these scribes participated each day. They would arise very early, attend – or even perform in – services, help with ordinary 'household' chores, visit poor parishioners, do some gardening etc, as well as having to prepare their parchment and vellum – cutting it to size, ruling-up the

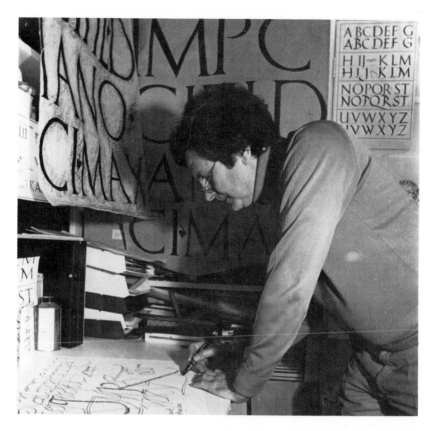

23 A study in concentration. Roman lettering from Wroxeter (the Roman city of Uriconium), nr Shrewsbury (AD 130) is from the entablature over the entrance to the Forum. It comes from the reign of the Emperor Hadrian, and lends a certain amount of atmosphere to the author's studio. See figure 44

24 A great deal of 'calligraphic' freedom can be achieved by using *two* felt-tipped pens in producing graphic images. The two pens being used here are held together by a single rubber band.

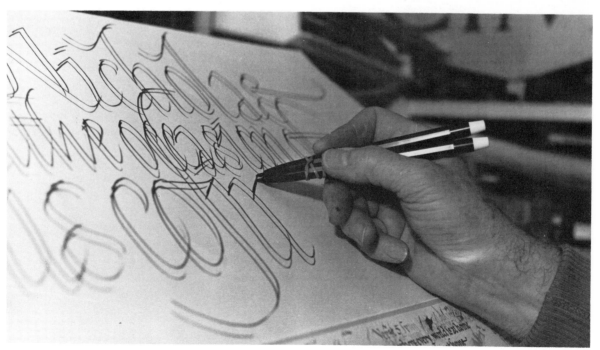

25 The author writing with a quill on a table-top easel which slopes at an angle of approximately 50 degrees to the horizontal

26 An interesting picture showing the scribe holding a 'reversed' brush in his left hand to press flat the paper on which he is writing. It is also possible to use an uncut quill or similar pointed implement for this purpose

24

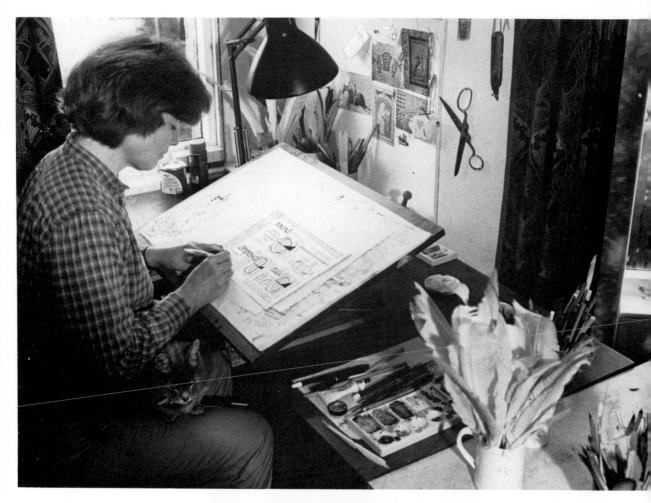

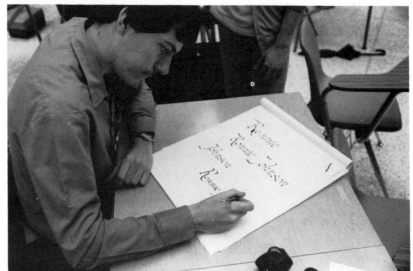

27 Ann Hechle in her working environment. She is using a table-top easel raked at a low angle which is determined by the personal needs of this expert calligrapher

28 A bad writing position has been adopted by this second year art/design student who is making his very first attempts at writing a formal script with a square-ended pen. He has an obvious aptitude but should be working on a sloping surface

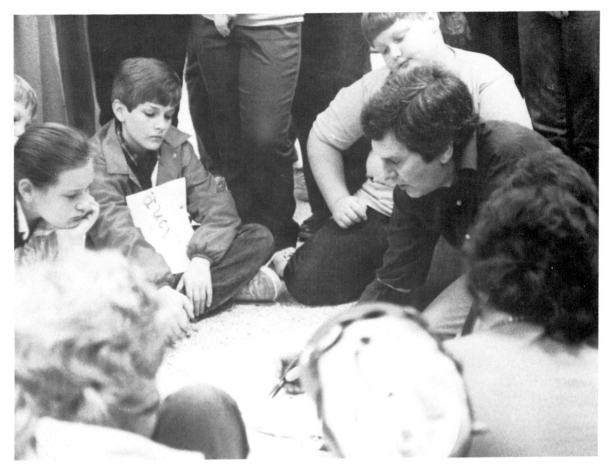

pages, and making the surface ready for a writing session, mixing their ink and cutting quills. The actual writing of manuscripts would be seen as another mundane task. The scriptorium could, in my opinion, be compared with the typist's office of today. It was simply a workshop which was there to facilitate visual communication through the written word, not necessarily a place which was in the business of producing works of art. Works of art resulted, and some were prepared specially by the instruction of bishops or other important people.

Such writing would be done at a natural speed. Some scribes would write quite quickly, others more slowly – just like you or me – but the letter forms they produced resulted from endless practise. It was not only monks who performed such works, for lay people in some cities, towns and villages were sometimes trained to assist. Indeed, it is reputed that the once flourishing scriptoria in Winchcombe and Cirencester, two small towns in the County of Gloucestershire, engaged local people as scribes. They probably taught them the rudiments of penmanship, invited them to work in their own scriptoria or expected them to do their work at home. Such activity must have been common practice throughout the country at that period.

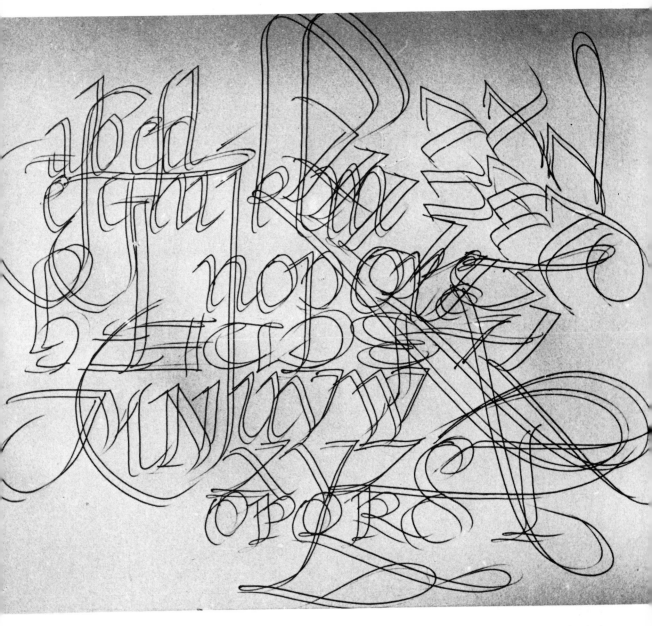

29 *Top left:* When teaching script I often like the freedom of working on the floor, with pupils or adults surrounding me. This creates a more intimate and relaxed atmosphere and everyone is close to the writing surface so that they can see clearly what I am doing. Here I am using a ball-point pen and a pencil taped together to produce the effect of the square pen

30 *Bottom left:* Here I'm showing two adults how to form some letters with a square-ended pen. I am

deliberately standing up and writing on an horizontal surface in order to demonstrate to them that this is *not* an ideal method of working

31 Quickly-written alphabet used to demonstrate a lecture. Black felt-tipped pen on card.

33

ADOPTING A GOOD WRITING POSITION

As a student I became accustomed to sitting *at a table, on a stool*, with a board on my knee. If I now sit on a chair, instead of a stool, I feel somewhat inhibited. A stool certainly tends to give more freedom but decide for yourself whether you use a stool or a chair.

A strong table – which won't wobble – makes a good work top. On the other hand, I have met calligraphers who have made their own simple work benches with blockboard tops and with raised pieces screwed to the backs and ends so that materials don't fall off. Such a simple idea is most effective.

I write at a table, or even, sitting in an armchair, on my knee. The board on which I write is as light in weight as possible and is either a piece of strong card or a piece of plywood (approximately 45 cm × 50 cm) purchased from a handimans' store.

Once you have decided on your working arrangement, sit at your table, place your drawing (or writing) board in your lap while letting it rest against the table or bench. *The writing angle* can easily be varied by moving yourself nearer to the work top. The most important thing is to feel comfortable and relaxed for if you are uncomfortable your writing will reflect this and become stilted. I alternate my methods, and often use my *Dart* table easel (see the relevant list of *Materials and Equipment* for details) for it is sturdy and affords me a firm writing position.

Now take up your pen, holding it in your normal writing position, and place your arm loosely against your ribs. Allow your writing hand to rest on your sloping board and where the pen meets it is *your* writing position. Any calligraphy should be done where your pen contacts the writing surface, which in itself sounds a stupid statement, but what I mean is that if, for instance, you stretch upwards from your normal writing position you will find that the letter-forms you produce will appear strained and, in any case, your arm will quickly tire. On the other hand, if you move your hand lower down the board your writing angle will change and your writing will become cramped and stilted.

THE WORK SURFACE

I suggest that you cover the drawing board with a piece of strong white card which can be taped to the board without much trouble. Now cover the lower part of the card-covered board – from your natural writing position downwards – with strong cartridge paper or card so that the paper (or vellum) on which you intend to write can be slotted behind it easily. This protects your writing surface and can be pinned or taped at the edges to hold it firm. You might find it helpful to have a second 'covering' sheet over the top part of your board, making sure that you leave a gap some 5 cm to 8 cm wide where your actual calligraphy will be done.

Try out some of these suggestions and decide whether they suit you. If not, use some other method.

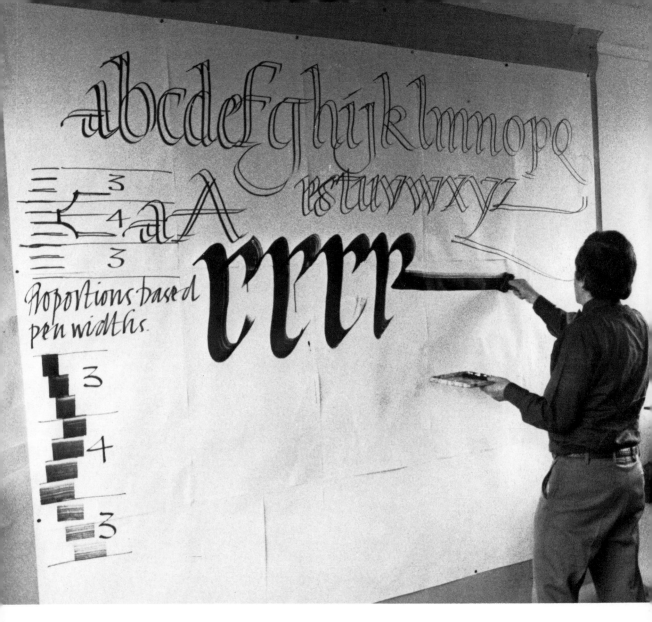

32 *Top left:* When I give a formal lecture I like to demonstrate on a number of both horizontal and vertical surfaces, ie blackboards or large sheets of paper or card. Here I'm attempting to produce a formal script with a piece of stick covered with cloth which has been dipped into black ink. It proved to be a clumsy instrument but illustrated a vital point in my talk

Photographs 28, 29, 30 and 32 are reproduced by courtesy of the John Calhoun State Community College, Decatur, Alabama, USA

34–35 (*overleaf*) Action shots of the author demonstrating formal round hand script to a large student group. Two types of improvised pens are employed:
(i) two felt-tipped pens taped together (figure 33) and
(ii) a 50 mm wide piece of felt 12 mm thick held in a bull-dog clip and dipped into black ink (figures 33 and 34). Both are relatively crude instruments denying the calligrapher the delicate fine lines which are produced by a quill – as can be seen in the ugly tail of the capital 'R' which was very difficult to produce from a low angle near to the floor – but they are ideal for writing very large, dynamic images which an audience in a large lecture theatre can see easily

4
PEN-MADE PATTERNS

Some people find it tedious to make pen patterns, preferring to move immediately into 'proper' writing, but I would stress the value of the former practice. Making pen patterns is like playing scales on the piano. It is a loosening-up procedure and develops the writer's skill, pen control and confidence. I can, however, understand the urgent desire to evade it and to go straight into writing. When I play golf I like to get on with the game. I do not want to stand for hours on a practice tee like the dedicated professional who will, apparently, hit more practice shots in one week than the weekend golfer does in a lifetime. In doing this he reaches near perfection and becomes a real artist, a true craftsman, and although the calligrapher will have emulated the golf professional, so that every pen letter he produces is done with what the Chinese would say is 'natural ease', it would be stupid to expect more than one percent of the readers of this book to do likewise.

All I would suggest is that a little time be given to the occasional production of a few pen patterns. Do this as a sophisticated form of doodling and you will, I am sure, find it a useful and relaxing experience.

I can make such patterns with a ball-point pen, pencil, a piece of chalk or pastel, or a square pen, and I like to write on a piece of ordinary exercise paper. The lines help me to retain a constant height so that I am not worried by unnecessary variation and, because of this, I develop a gentle rhythm quickly. It is interesting to compare writing to dancing and to consider timing carefully. For instance, when you are doing a line of 'V' shapes, do these in 2/2 time, saying 1 – 2, 1 – 2, to yourself.

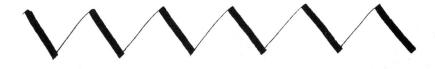

Curved lines lend themselves very well to a waltz rhythm – 1 2 3, 1 2 3, 1 2 3 – or press *and* lift, press *and* lift

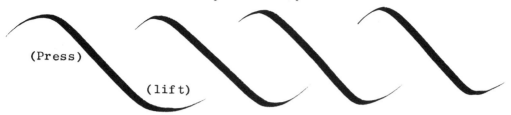

(Press)

(lift)

You can obviously vary the timing and rhythm a little but I would suggest only 3 or 4 so that you don't get confused.

Look at the pen patterns shown here and work out some dance times and rhythms. Try placing a piece of paper over them and trace through with a pencil, ball-point or square pen.

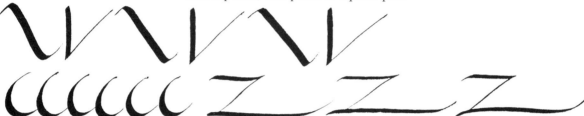

Pen patterns are invaluable in developing confidence, rhythm and writing skills.

The simple diagram below shows the directions of pen strokes, and angles in relation to their heights.

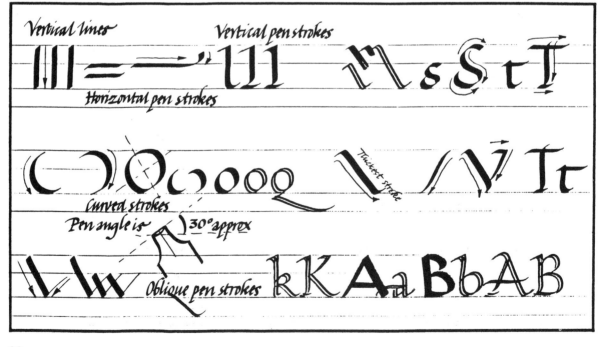

36 Pattern of strong lines
produced with an *Edding* 1255
calligraphy pen (0.5)

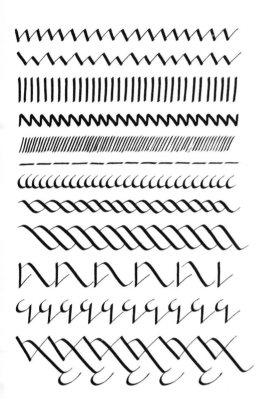

37 Simple patterns like these can be made with a pencil, ball-point, felt-tipped or square pen. They can be copied, traced and done freehand to help you develop a feel for pen and paper

38 More patterns to copy. After a little practice you should invent some of your own and try covering pages with them. Remember that the more patterns you do the more control you will have over your writing implements and the better will be your later attempts to write well.

39 These basic patterns are made with a square-ended pen. They were done quickly to develop a rhythmic skill as well as to build up confidence

5
A FORMAL
ROUND HAND

If you have practised making pen patterns you will have discovered how to control the pen, the flow of ink on to the writing surface, and the rhythmical movements which are essential to good penmanship. You might have concentrated your endeavours with an *Edding* fibre-tipped calligraphy pen, and this will have strengthened your technique and confidence. I suggest that before you do any writing you perform some 'five-finger exercises' simply to loosen up – these are your pen patterns.

FORMAL CALLIGRAPHY

We now come to more formal calligraphy. I shall concentrate on a round hand which is based on tenth-century scripts from the Winchester scriptorium. Edward Johnston studied various scripts and decided that the Winchester Round Hand was the most beautiful. It is characterised by its *roundness* and the harmonious relationship of the letter strokes, spacing and uniformity.

A round hand is done with a square-ended pen (sometimes known as a broad-nibbed pen), which produces broad and thin strokes (thicks and thins). The pen must be held at a constant angle, and although some authorities maintain that this should be 30° to the horizontal writing line, I suggest that it depends upon the physical make-up of the individual, who must write in a comfortable position.

The relationship of the broad nib to the height and size of the letters is very important, and to determine this the pen is turned sideways on so that the width of the nib can be used to produce guide lines. Tenth-century Winchester scripts were based on the following pen widths:

MAJUSCULE (CAPITAL) LETTERS = 7 pen widths
Minuscule (lower case/small) letters = 4 pen widths for the body of each letter with the *ascenders* – the strokes which go up above the body of these letters – going up to the height of the Majuscules (ie 7 pen widths), and the descenders – the strokes which go down below the writing line – going down 3 pen widths.

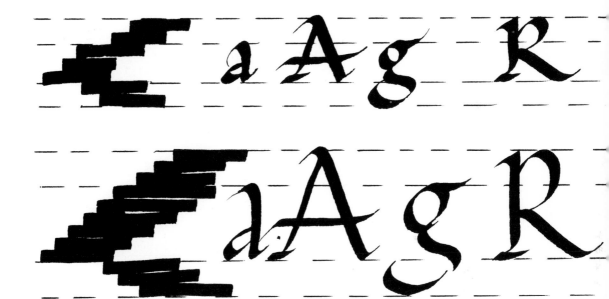

3
4
3

If these proportions are changed we see that the characters of the letters also change:

2
3
2

3
6
3

These two factors – the pen held at a constant angle of approximately 30° and the proportion of pen widths to letter heights – are also related to the beginnings and endings of the letters – the serifs. The simplest 'beginning' serif is simply a thin line

the simplest 'ending' serif is a kind of curve or hook

The Winchester scribes, however, started-off their letters with what I call a 'chisel-shaped' serif

This is made with *three* pen strokes:

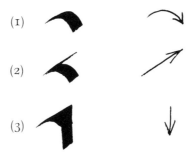

(1)

(2)

(3)

It requires the same attention to rhythmical performance as any other part of a letter and must be practised.

The curved endings or finishes of letters are often simply curved shapes.

E John Milton-Smith, the Yorkshire calligrapher who featured in my previous book, *Lettering Techniques*, gives his elementary directions for the construction of a Foundation Hand. As he and I were students together, under a student of Johnston's, it is easy to see the similarity of the writing we produce (Figures 40 to 43).

THE FOUNDATION HAND

Basic strokes: the pen should be held so that the nib makes an angle of 30–40 degrees to the horizontal. Holding the pen at this constant angle should produce the characteristic strokes which start and terminate in serifs, hooks or flourished strokes – note the direction and sequence of making the above strokes.

abcdefghijklmn
opqrstuvwxyz.

In a basic minuscule alphabet, using the appropriate variations of the pen movements shown above, 'O' is the key letter. Round in form, it gives the open character to the hand. There are acceptable variations to letters a; g; v; w; and y.

ABCDEFGHIJK
LMNOPQRST
UVWXYZ.

A basic majuscule alphabet for use with the above minuscule letter forms. Where appropriate calligraphers sometimes use variations of letters such as E; F; G; H; M; T; U; and W based upon the rounder 'Uncial' majuscules. With practise and discretion certain strokes may be flourished to good effect.

1234567890&.

40 Example of foundation hand by E John Milton-Smith

Arabic numerals for use with the above alphabets – occasionally only 1 and 0 are written between the lines, even numbers rising above, odd numbers going below.

YOUR ROYAL HIGHNESS
TO Lieutenant PHILIP MOUNTBATTEN.
WE have observed with joy the ever increasing affection
which the peoples of the country and empire have
shown towards Your Royal Highness and the universal
acclamation of your forthcoming marriage.
The real interest shown in the public duties undertaken
by Your Royal Highness especially among young people
has endeared you in the hearts of all His Majesty's subjects
and won their general respect and honour.
WE humbly pray that Your Royal Highness may find
true happiness in your future life and may continue
in the high regard so justly accorded to the Royal Family.

41 Example of writing by Thomas Swindlehurst, who had been a student of Edward Johnston at the Royal College of Art

42 Example of round hand by Edward Johnston. From *'Formal Penmanship' by Edward Johnston (edited by Heather Child) published by Lund Humphries, London (Detail from plate 15)*

43 *Facing page:* In this illustration of majuscule letters (round hand capitals) are compared with capital letters from the inscription on Trajan's Column, Rome. In the four horizontal bands the Trajan *incised* letters are placed directly above those produced with a quill, and demonstrate quite clearly that respective shapes and proportions are almost identical

Majuscule letters, standing 7 pen widths high, have a majesty of character which stems directly from their Classical ancestors. I demonstrate this in figure 43 where Roman letters from the incised inscription at the base of Trajan's Column in Rome are placed above my own variation of the tenth-century Winchester majuscules. The following facts emerge:
 – The proportions of both sets of letters are similar.
 – The shapes of the letters are almost identical.
 – The serifs of the Trajan caps are obviously derived from the hammer and chisel while those of the script forms stem directly from the quill pen and ink.
It is a known fact that 'small' letters, the lower case or minuscules grew out of their majuscule relatives, changing over the years until they became very beautiful Carolingian-type round-hand scripts in the tenth century. This metamorphosis is indicated in figure 45.

Create— thy senses close
With the world's pleas. The random odours reach
Their sweetness in the place of thy repose,
Upon thy tongue the peach,
And in thy nostrils breathes the breathing rose.

ABCDEF G
ABCDEF G

HIJ - KLM
HIJ - KLM

NOPQR ST
NOPQRST

UVWXYZ
UVWXYZ

41

44 *Facing page:* Detail from one of six sheets of rubbings taken from actual fragments of the entablature over entrance to the Forum, Wroxeter – Roman City of Uriconium, nr Shrewsbury. *Reproduced by courtesy of F Palmer Cook.* See figure 23

45 An example by John Lancaster of majuscule to minuscule

46 *Above:* E John Milton-Smith's experiment in which he used two ball-points as one pen and superimposed all the letters of the alphabet

HOW TO DO A ROUND HAND SCRIPT

We don't know how the scribes learned to write in the monasteries. There might have been formal teaching of some kind in which classes of young monks were taught by experienced scribes. My guess is that it was probably done on a one-to-one basis, with a novice assigned to a scribe in a 'master-apprenticeship' fashion in which he would sit and watch the scribe at work. In this way he would learn the rudiments of the craft – seeing how pages of vellum were prepared and lined up ready for writing; how a quill was cut; how the experienced monk ground his inks, etc, and how he went about the task of writing. Some of the young novices would soon acquire the art of writing and become experts, others would learn that it was a serious and difficult thing to do and would leave the scriptorium to take up other duties.

When I was a student I was taught by my tutor how to use a square pen. He would sit down and write an alphabet on paper and I tried to copy it.

43

After a great deal of work he would return and explain to me how I should set about writing one or two letters, and I would practise and practise again. Gradually I learned how to do my version of the tenth-century round hand which he himself was proficient in writing.

This is one way of learning this craft. But many readers will be trying to do it alone, with no tutor available to help. What I have attempted in this section is to design a simple strategy which I hope will fulfil this need, and I am grateful to E John Milton-Smith for unwittingly starting me thinking.

A few weeks' ago John gave me a photocopy of an alphabet which he had scribbled quickly with a two-pointed pen (in actual fact two ball-point pens taped together) in demonstrating a teaching point to some students. Illustration 46 shows that he had written the twenty six letters of the minuscule alphabet one on top of the other. He pointed out that it is interesting to note that the preponderance of strokes which form the letters are based on the letter 'O', or are contained within its shape. Therein, he claimed, would seem to be the character of this alphabet – an alphabet in which each letter is different but which conforms to a sense of overall unity.

I decided to experiment for myself, using circles as a foundation for each letter of the minuscule alphabet. My sketch-book notes indicate my first attempts. (Figures 47 and 48.) I was astonished how helpful this circular framework was – although I very often write without the aid of lines of any kind – and it made me think that amateurs working alone might also find such a basic underpinning to their first struggles at calligraphy of help; so I designed a 'structural sheet'. (Figure 49.) This is based upon *three* writing lines in which the tenth-century letter proportions emanate from pen widths (7 for majuscules, 4 for minuscules, 3 for ascenders and 3 for descenders). A series of circles was now drawn, each circle resting on a *writing line* and being the exact size of a minuscule letter 'O'.

The penning of a formal script, using these circles as guides, was relatively easy and I was astonished at the resulting relationships. The curved shapes of the circles was helpful in determining the 'rounded' letters, while the dotted lines proved to co-exist with certain parts of some letters, ie a, e, i, j, k and s. Even the width of the letter m tended to correspond well with the circle while the x and z went right through the centre points. (Figures 50 to 55.)

It was easy to apply the same principle to the majuscule alphabet (figure 56 and 57). Once again I was interested in the results and the actual relationships of the letters to their circles. Experiment yourself with the help of the structural sheet on page 47. I hope you gain confidence quickly and that you are helped to develop your own tenth-century-based Majuscule script by this method.

In figure 58 I was experimenting with letter forms on a structural sheet that I had photocopied.

I am now convinced that E John Milton-Smith had a valid point, for I found it easier to work with this framework and am in no doubt that if I had been introduced to it as a young student I would have learned the art

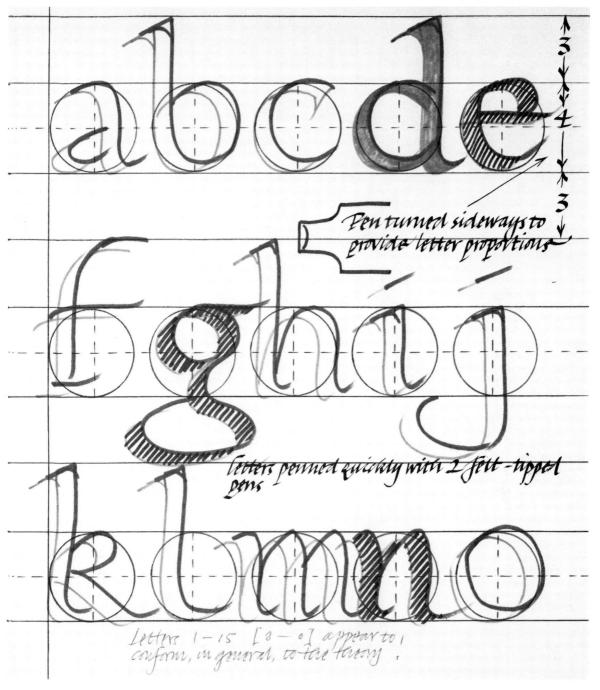

Pen turned sideways to
provide letter proportions

letters penned quickly with 2 felt-tipped pens

letters 1-15 [a - o] appear to conform, in general, to the theory.

of calligraphy much quicker. Some traditionalists will not welcome this approach but, as this book is essentially for beginners, I feel it is a legitimate learning aid and should be a helpful starting-off point.

47 First experimental test sheet concerned with E John Milton-Smith's ideas re 'O' being the basic character form – minuscule

45

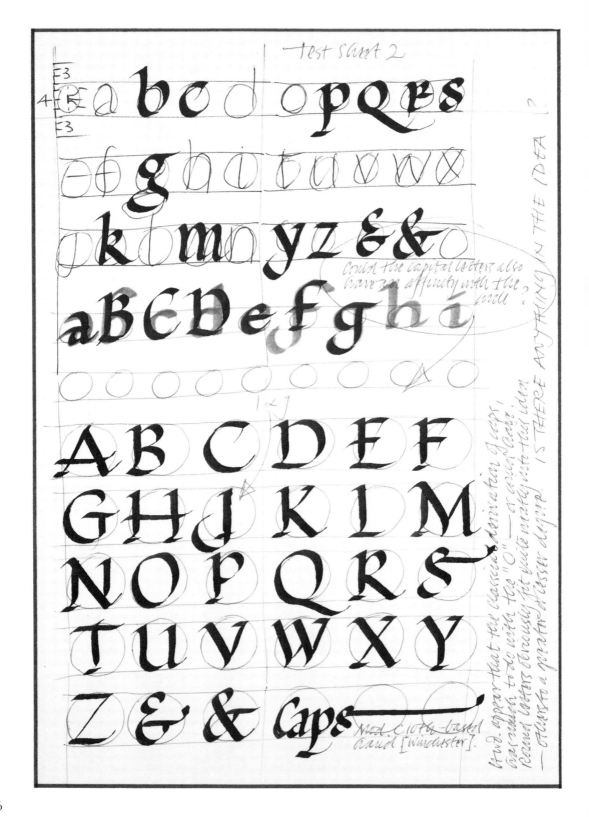

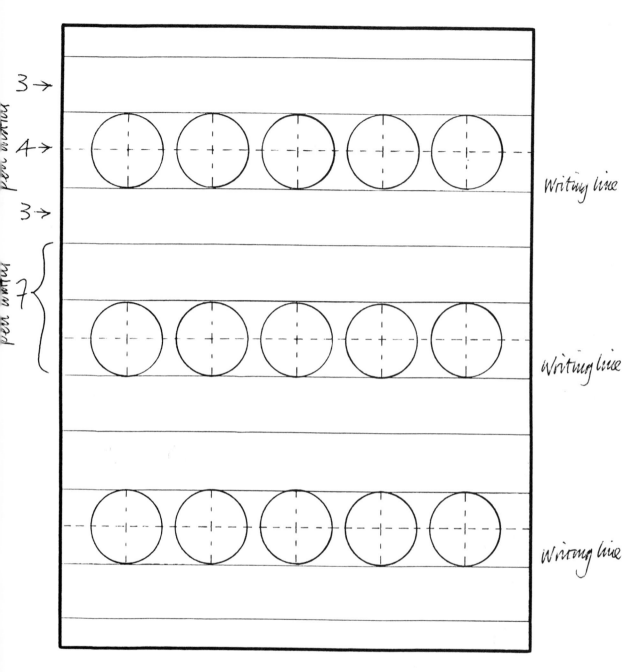

3 →
4 →
3 →
7

pen width
pen width

Writing line

Writing line

Writing line

49 Structural sheet. I suggest
that you place a sheet of flimsy
typing paper over this and trace
the guide lines which will help
you to practise this method

48 *Facing page:* Sketch book
scribbles

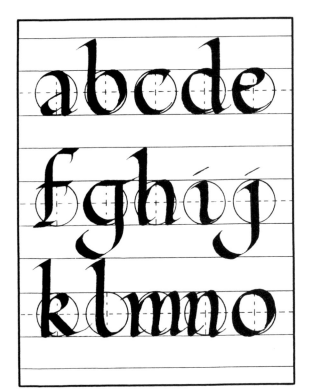

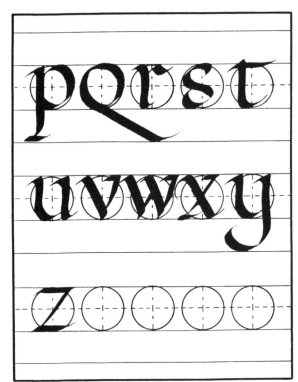

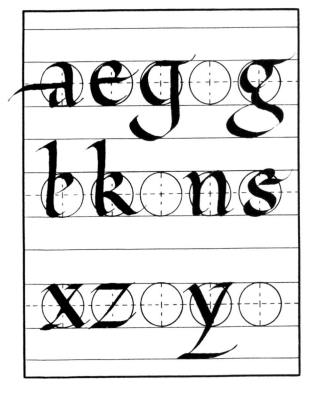

abcde
fghij
klmno

50 to 57 Penning of formal
script using circles as guides

48

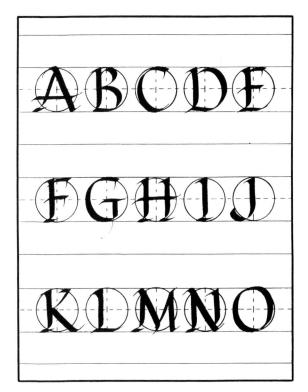

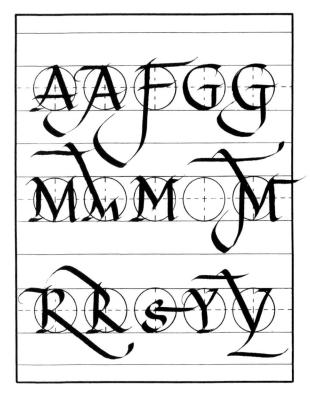

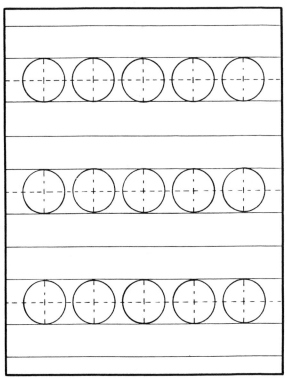

55 to 58 (*overleaf*) Same
principle applied to the
majuscule alphabet

49

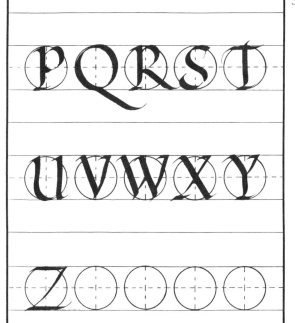

59 These alphabets were written freely without the aid of ruled lines

60 *Facing page:* Loyal Address by Irene Wellington, presented to H M The Queen by the London County Council on her Accession. *Reproduced by courtesy of the Lord Chamberlain*

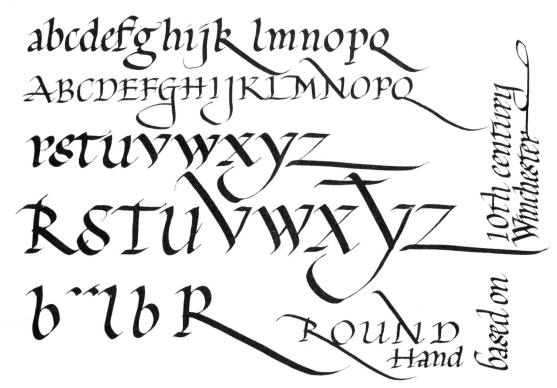

abcdefghijk lmnopq
ABCDEFGHIJKLMNOPQ
rstuvwxyz
RSTUVWXYZ
b ʿ ͳ b ʀ

ROUND
Hand

based on 10th century Winchester

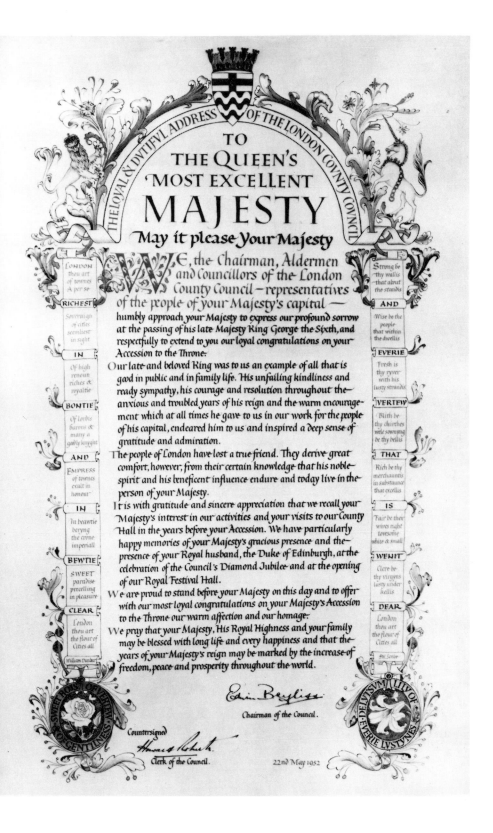

THE LOYAL & DVTIFVL ADDRESS OF THE LONDON COVNTY COVNCIL

TO
THE QUEEN'S
MOST EXCELLENT
MAJESTY
May it please Your Majesty

WE, the Chairman, Aldermen and Councillors of the London County Council — representatives of the people of your Majesty's capital —

humbly approach your Majesty to express our profound sorrow at the passing of his late Majesty King George the Sixth, and respectfully to extend to you our loyal congratulations on your Accession to the Throne.

Our late and beloved King was to us an example of all that is good in public and in family life. His unfailing kindliness and ready sympathy, his courage and resolution throughout the anxious and troubled years of his reign and the warm encouragement which at all times he gave to us in our work for the people of his capital, endeared him to us and inspired a deep sense of gratitude and admiration.

The people of London have lost a true friend. They derive great comfort, however, from their certain knowledge that his noble spirit and his beneficent influence endure and today live in the person of your Majesty.

It is with gratitude and sincere appreciation that we recall your Majesty's interest in our activities and your visits to our County Hall in the years before your Accession. We have particularly happy memories of your Majesty's gracious presence and the presence of your Royal husband, the Duke of Edinburgh, at the celebration of the Council's Diamond Jubilee and at the opening of our Royal Festival Hall.

We are proud to stand before your Majesty on this day and to offer with our most loyal congratulations on your Majesty's Accession to the Throne our warm affection and our homage.

We pray that your Majesty, His Royal Highness and your family may be blessed with long life and every happiness and that the years of your Majesty's reign may be marked by the increase of freedom, peace and prosperity throughout the world.

Edwin Bayliss
Chairman of the Council.

Countersigned
Clerk of the Council.

22nd May 1952

Left margin:
LONDON thou art of townes A per se
RICHEST
Soveraign of cities seemliest in sight
IN
Of high renoun riches & royaltie
BONTIE
Of lordis barons & many a gudly knyght
AND
EMPRESS of townes exalt in honour
IN
In beawtie beryng the crone imperiall
BEWTIE
SWEET paradise precelling in pleasure
CLEAR
London thou art the flour of Cities all
William Dunbar

Right margin:
Strong be thy wallis that about the standis
AND
Wise be the people that within the dwellis
EVERIE
Fresh is thy ryver with his lusty strandis
VERTEW
Blith be thy chirches wele sownyng be thy bellis
THAT
Rich be thy merchauntis in substaunce that excellis
IS
Fair be their wives right lovesome white & small
WENIT
Clere be thy virgyns lusty under kellis
DEAR
London thou art the flour of Cities all
W. Scott

"Pole is no town of auncient occupying in merchandise; but rather of old tyme a poor fishar village and a hamlet, or member of the paroch church. It is, in hominum memoria, much encreased with fair building and use of merchandise. There be men alive that saw almost all the town of Pole kyverid with segge and risshis."

John Leland (1506-52)

INTRODUCING SOME INFORMALITY

With practise, formal writing can be mastered and section 7 deals with its use in 'designed' work. It is helpful to add to one's confidence, however, by using a pen freely – whether this be a fibre-tipped pen, a metal nib, a couple of taped-together ball-points or a quill – and to write some informal letters.

The tenth-century majuscule forms may be interpreted freely. (Figure 62.) Here I have worked rapidly and refused to use serifs – in a formal sense – while making the shapes a little more angular. The alphabet of 'Decorative Capitals' was really enjoyable to produce. It was done with an *Edding* fibre-tipped pen. In figure 63 I combined this style with a line or two of minuscule and wrote 'Whither you look thither shall you fly'.

Jean Larcher, the French calligrapher, has produced the vigorously-penned alphabet shown in figure 65.

Try a little experimentation yourself. Draw some guidelines if you feel these would be helpful, otherwise do what I often do and just use your pen.

61 Page of a manuscript book in formal script written by E John Milton-Smith

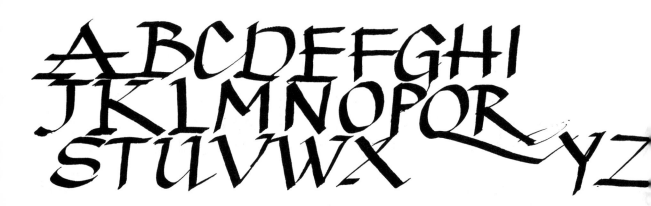

62 Alphabets designed by the author based upon tenth century round hands

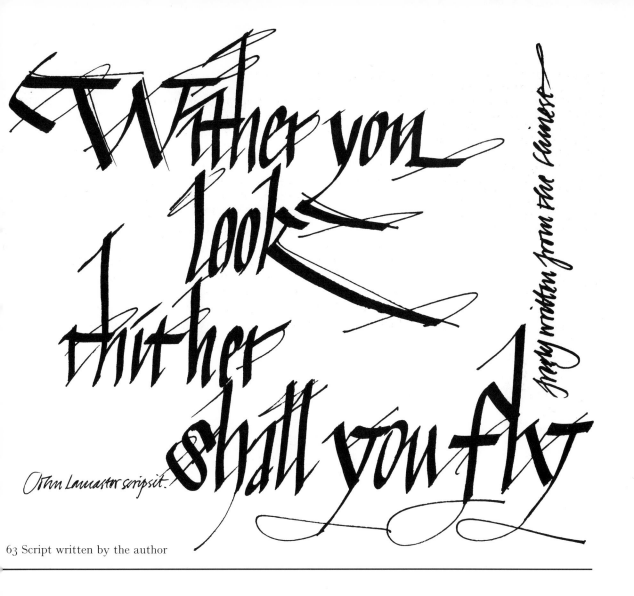

Wither you look thither shall you fly

John Lancaster scripsit.

freely written from the Clarinet

63 Script written by the author

abcdefghijklmnopq
stuvwxyz

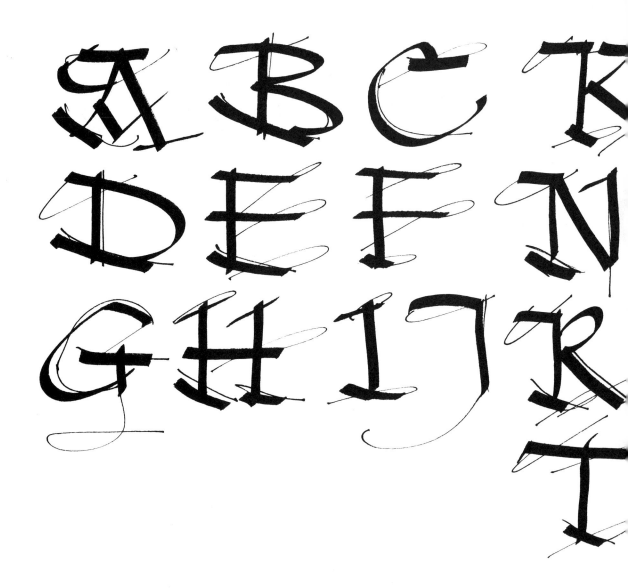

64 Decorative capital letters written freely by John Lancaster with a broad

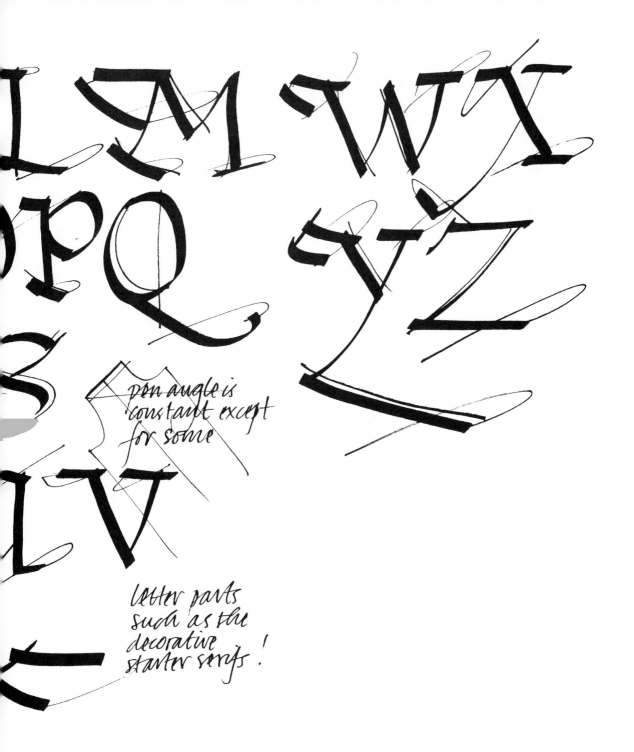

pen angle is
constant except
for some

letter parts
such as the
decorative
starter serifs!

felt-tipped pen for use with areas of 'massed' script

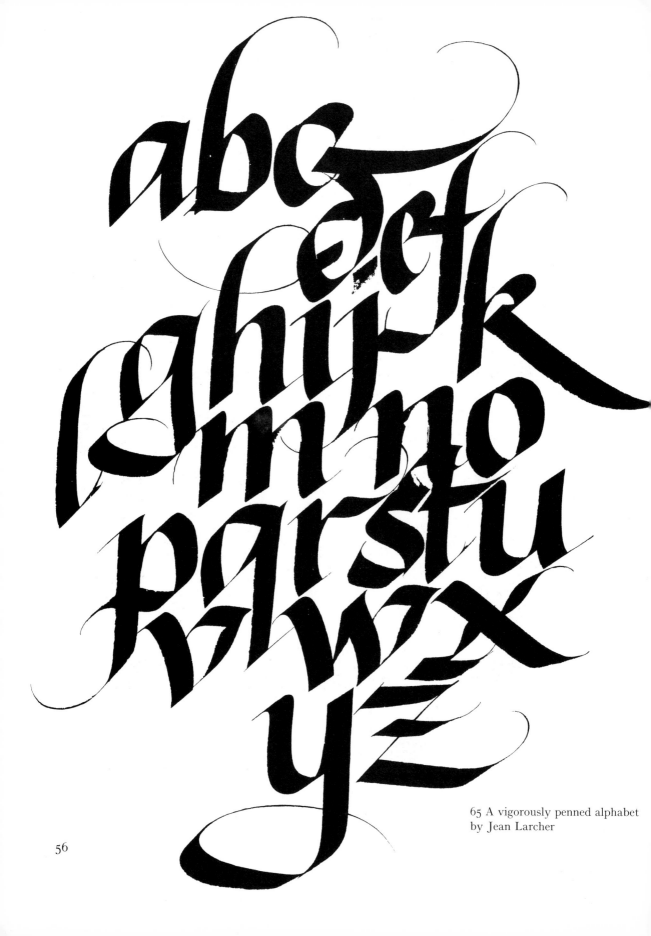

65 A vigorously penned alphabet
by Jean Larcher

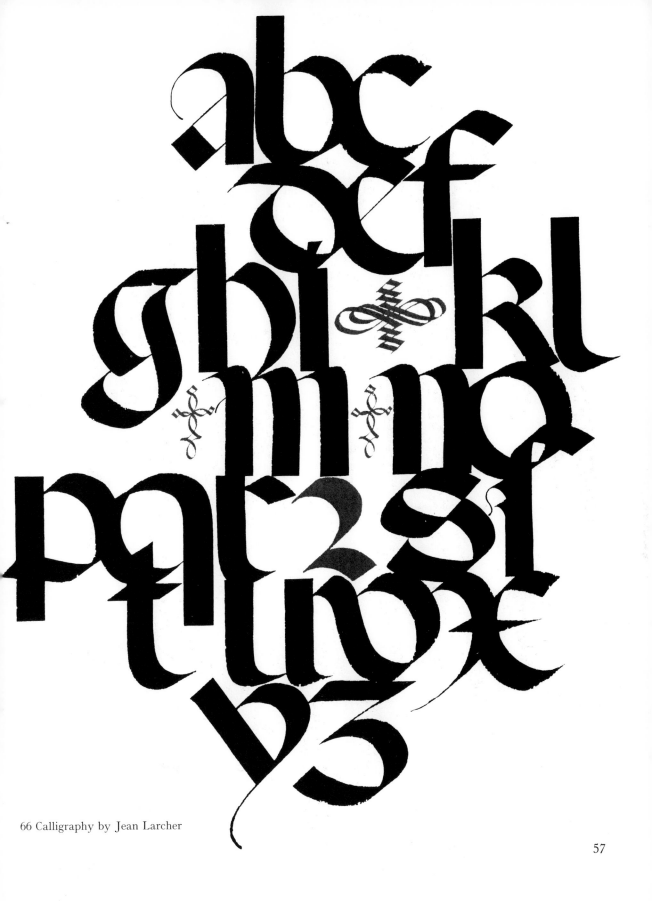

66 Calligraphy by Jean Larcher

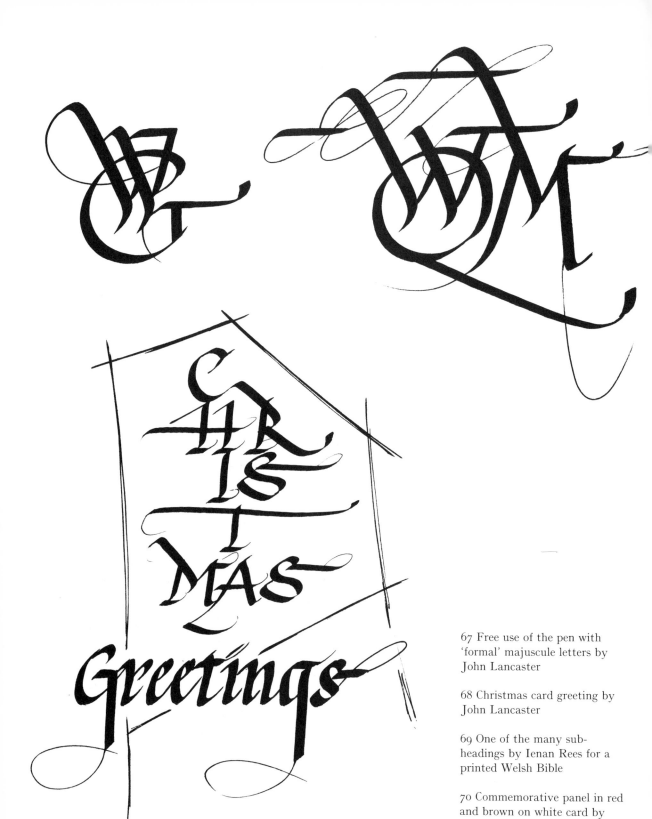

67 Free use of the pen with 'formal' majuscule letters by John Lancaster

68 Christmas card greeting by John Lancaster

69 One of the many sub-headings by Ienan Rees for a printed Welsh Bible

70 Commemorative panel in red and brown on white card by John Lancaster

Blynyddoedd Cynnar yr Iesu

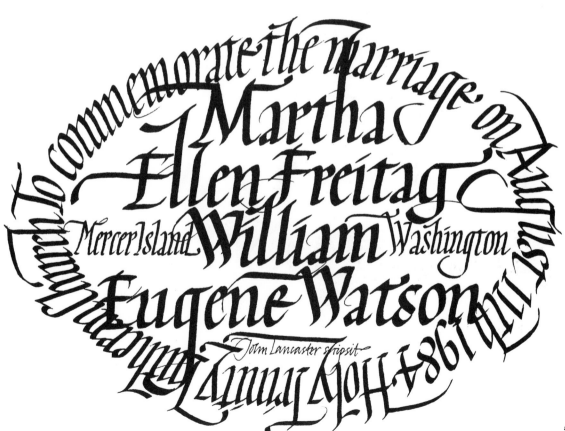

To commemorate the marriage, on August 11th 1984, of Martha Ellen Freitag and William Eugene Watson at Holy Trinity Lutheran Church, Mercer Island, Washington

John Lancaster scripsit

59

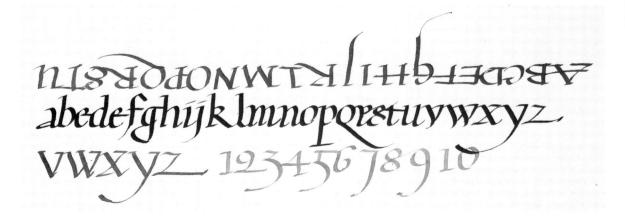

(1.) The simplest Terminal is a CROSS-STROKE as in these Skeletons [NOTE: the horizontals of B,D,E, &c. take the place of cross-strokes] [likewise A,M & N,(V) may use their own strokes (or be left, AMN)] Such letters may be called 'SQUARE' or 'CROSS-TOPPED': with some desirable inconsistencies, the Slanted-PEN forms are here given.

ABCDEFGHIJKLMNOPQRSTUVWXYZ

ABCDEFGHIJKLM
NOPQRSTUVWXYZ

(2.) ROUNDER forms (v. UNCIAL, pl.3) - finished generally with their own curves & hooks — have been developed from the Roman Capitals: these may be called the 'ROUND' or BRANCH-TOPPED' letters: the Slanted-PEN forms are given here.

[CC] BD & DEFGHK[L]MNPRSTUW

BDDEFGHKMNR
PSTU

OR for a more formal MS. 'heads' & 'feet' may be added thus:

[e.g. these would match very well with the letters of No. 1.]

BDDFHKNPRT

71 Alphabet of semi-formal
script by John Lancaster

72 Slanted-pen capitals. *Detail
from plate 6. School Copies and
Examples, No 2. published 6,
Pitman*

Calligraphy is the
servant of thought
& language to
which it gives us
visible existence

73 Tenth century up-dated
formal hand written by Malcolm
Drake

74 Calligraphy by Lilly Lee

The
essence of
Gothic art is freedom to do
the best you can.
It is not a matter of pointed
arches, of angular lettering.

An Essay on
Typography by Eric Gill

Plain letteri
when proper
and rationally p
has all the
of pl

6
ITALIC SCRIPT

An italic script is generally done with a narrower nib than a formal round hand. The letters are compressed a little, unlike the roundness of the kind of script we have been dealing with in the previous section, with its ascenders and descenders elongated.

This script may be used for both informal and formal work – for the body of text in a book, for instance; on scrolls; or to add decorative lettering effects. Indeed, it may be juxtaposed with more formal round hands to add variety to a piece of calligraphy, and versions of it provide decorative titlings which can be most effective.

The letters are formed with a square-ended pen, which must be held at a constant angle – usually about 30° to the writing line – and the calligrapher may apply a little more freedom when he executes the letters. These should be slightly compressed, giving an angular character and should slope forward from the vertical so that the eye is carried forward.

ITALIC HANDWRITING

This form of handwriting follows closely the characteristics of formal italic script. It originated in the sixteenth century (figure 84), and early this century it was 'modernised' by calligraphers who wished to get away from nineteenth century *Copper Plate* models.

Like all handwriting, it is best written with confidence, conviction and speed. A square pen is an essential instrument and, for normal letter-writing, I would use a number 4 (or less) William Mitchell round hand metal nib, or a fountain pen which has been made specifically for this purpose. Often I am lazy and simply pick-up a ball-point or fibre-tipped pen such as a *Berol* 'Italic Pen'.

Individual styles vary. Some are more rounded while others are characterised by compressed letters and angularity. (Figures 75 to 112.)

abcdefghijklmn
opqrstuvwxyz

ABCDEFG
HIJKLMN
opqrstuvwx
yz

abcfgkry

75 An italic minuscule alphabet
and the effect of further
elongation upon certain letters

76 This is the majuscule version

Minuscule letter forms (round or more pointed) are compressed, giving
more letters to a line and sloping in the direction of reading (not more than
5 degrees). Ascenders and descenders may have serifs or be flourished.

abcdefghijklmnopqrstu
vwxyz bd ch pr ly

77 Italic hands by E John
Milton-Smith

ABCDEFGHIJKLM
NOPQRSTUVWXYZ

Majuscule letter forms to use with the above Italic hand – certain strokes, where appropriate, may be extended and flourished and thus be quite decorative. In the more decorative form these are referred to as 'Swash Letters'.

EGHMTUSWL

Alternative majuscule forms are sometimes preferred – the above, based on 'Uncial' forms are in certain cases showing Gothic or Lombardic tendencies. Such letters are often useful as Initials or for titles and headings. *Spacing:* The areas of space between letters should *look* equal. When two curved letters occur together, the space between should only be slight.

oo n mainwbcpe

A curved stroke next to a straight stroke needs a little more space. Two straight strokes occurring together need the most space. *Words:* The space between words should not normally be more than the width of a small 'o'.

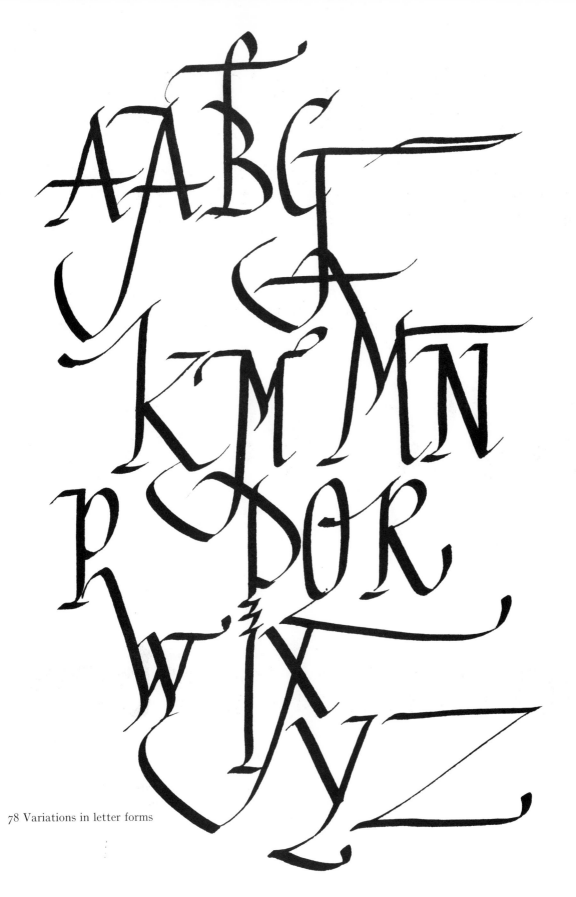

78 Variations in letter forms

abcdefghijklm
noporstu vw
xyz

Written by means of two pencils
taped together, the resulting shapes
were then completed with a brush
and silk screened on to plastic.
EJMS.

At the moment of meeting, the parting begins

from the Chinese 1985

John Lancaster scripsit

79 An italic alphabet by E John Milton-Smith written with two pencils taped together and the resulting shapes being completed with a brush and silk-screened on to plastic

80 Three lines of italic writing freely written by John Lancaster

81 Letterheads designed by John Poole in an italic hand

82 *Facing page:* Lettering by Ann Hechle

'Cedarwood'· Levington · Ipswich · Suffolk · Telephone · Nacton 331

"Mill House," 54 Bell Lane, Kesgrave, Ipswich IP5 7JQ
TELEPHONE: IPSWICH 622818

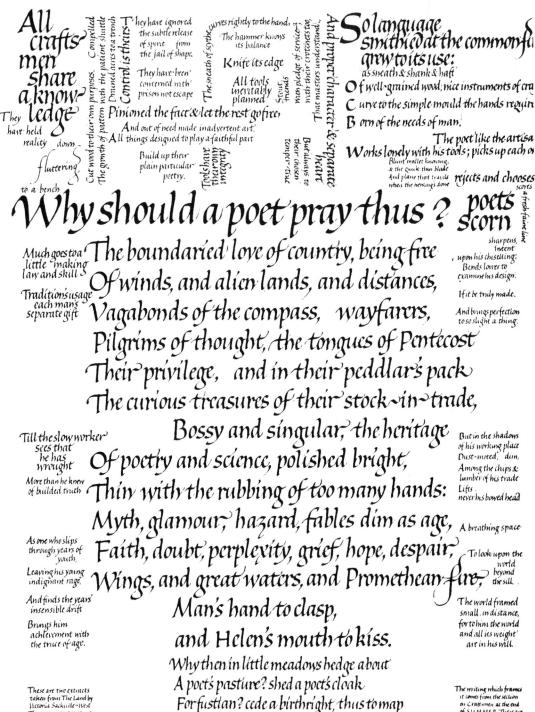

All crafts men share a know ledge
They have held reality down —
fluttering
to a bench

Compelled
Cut wood to their own purposes. Compelled
The growth of pattern with the patient shuttle
Drained acres to a trench

Control is theirs
They have ignored the subtle release of spirit from the jail of shape.
They have been concerned with prison not escape

Pinioned the fact & let the rest go free;
And out of need made inadvertent art.
All things designed to play a faithful part

Build up their plain particular poetry.

The sneath of scythe

curves rightly to the hand,
The hammer knows its balance
Knife its edge
All tools inevitably planned

Stout friends with pledge of service with their cretistes too
That masters understand
But always to their chosen heart

Tools have their only integrity
Tools have their chosen temperament

And proper character & separate heart

So language smithied at the common fa[ir]
grew to its use:
as sheath & shank & haft
Of well-grained wood; nice instruments of cra[ft]
Curve to the simple mould the hands requir[e]
Born of the needs of man.

The poet like the artisa[n]
Works lonely with his tools; picks up each o[ne]
Blunt mallet knowing,
& the quick thin blade
And plane that travels when the shaving's done
rejects and chooses

poets scorn

scorns a fresh-faced line

sharpens, intent upon his chiselling;
Bends lower to examine his design.

If it be truly made.

And brings perfection to so slight a thing.

Why should a poet pray thus?

Much goes to a little making law and skill

Tradition's usage each man's separate gift

The boundaried love of country, being fire
Of winds, and alien lands, and distances,
Vagabonds of the compass, wayfarers,
Pilgrims of thought, the tongues of Pentecost
Their privilege, and in their peddlar's pack
The curious treasures of their stock-in-trade,
Bossy and singular, the heritage
Of poetry and science, polished bright,
Thin with the rubbing of too many hands:
Myth, glamour, hazard, fables dim as age,
Faith, doubt, perplexity, grief, hope, despair,
Wings, and great waters, and Promethean fire,
Man's hand to clasp,
and Helen's mouth to kiss.
Why then in little meadows hedge about
A poet's pasture? shed a poet's cloak
For fustian? cede a birthright, thus to map
So small a corner of so great a world?

Till the slow worker sees that he has wrought
More than he knew of builded truth

As one who slips through years of youth,
Leaving his young indignant rage,
And finds the years' insensible drift
Brings him achievement with the truce of age.

But in the shadows of his working place
Dust-moted, dim,
Among the chips & lumber of his trade
Lifts never his bowed head

A breathing space
To look upon the world beyond the sill.

The world framed small, in distance, for to him the world and all its weight' art in his will.

These are two extracts taken from The Land by Victoria Sackville-West. The main passage comes from the opening stanzas of WINTER and is preceded by the following lines, which run thus:
I have refused the easier uses of made poetry, But no small ploy disdain to chronicle.

And {like that pious yeoman laid to rest Beneath the legend that told all his life In five hard words: 'He tilled the soil well'}
Prune my ambition to the lonely prayer That I may drive the furrow of my tale Straight, through the lives and dignities I know.

The writing which frames it comes from the section on Craftsmen at the end of SUMMER. These are two contradictory but complementary ideas. The first asks Why should poets be confined? Their vision embraces the whole world. The second states that in order to communicate any idea it has to be channelled thro' some kind of form.

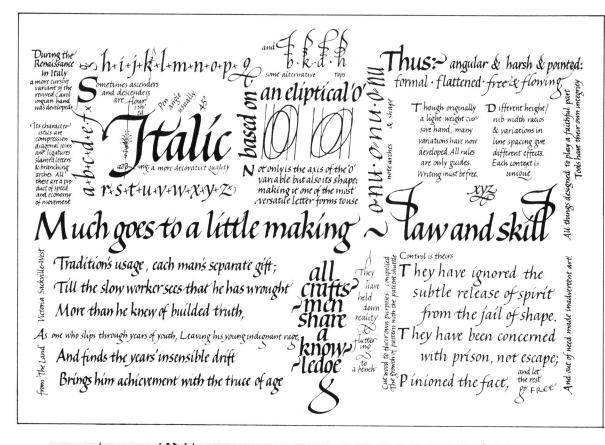

During the Renaissance in Italy a more cursive variant of the revived Carolingian hand was developed

‹Its characteristics are compression, diagonal joins and ligatures, slanted letters & branching arches. All these are a product of speed and economy of movement

a+b+c+d+e+f+x

Sometimes ascenders and descenders are flourished

h+i+j+k+l+m+n+o+p+q

Pen angle usually 45°

Italic

adding a more decorative quality

r+s+t+u+v+w+x+y+z

Z based on an eliptical 'o'

Not only is the axis of the 'o' variable but also its shape: making it one of the most versatile letter forms to use

and b·k·d·h some alternative tops

note arches & shape

Thus:– angular & harsh & pointed: formal · flattened · free & flowing

Though originally a light-weight cursive hand, many variations have now developed. All rules are only guides. Writing must be free.

Different height/nib-width ratios & variations in line spacing give different effects. Each context is unique

xyz

All things designed to play a faithful part. Tools have their own integrity.

Much goes to a little making ~ law and skill

Tradition's usage, each man's separate gift;

Till the slow worker sees that he has wrought

More than he knew of builded truth,

As one who slips through years of youth, Leaving his young indignant rage,

And finds the years' insensible drift

Brings him achievement with the truce of age

from 'The Land' Victoria Sackville-West

all crafts-men share a know-ledge

They have held down reality fluttering to a bench

Cut wood to their own purposes, compiled. The growth of pattern with the patient shuttle

Control is theirs

They have ignored the subtle release of spirit from the jail of shape.

They have been concerned with prison, not escape;

Pinioned the fact, and let the rest go FREE

And out of need made inadvertent art.

R... D. Cor... Collegium aggregasse. Quam dignitate mihi meri-
to credita, optica pietate, cupiens Patrum uestigiis inherere, illi si-
gnifico, nó minus ad obsequia, gratag3 seruitia Maie tis tue m
entiq3 regni tui ac tuor omniú q ad ornamentum persone mece:
usumq3 Senen: Patrie Futura. Quare S. Maie tis Tua rogo, atq3
obnixe obsecro ut me Seruitore suu ac reliquias Pij .iij. ample
Eti digneture: et opera mea ubi opus erit uti dignetur. inueni
et nepoti a patruo nó degenerare. Foelix Valeat S. M. Tua tis
cui me ex animo Comendo: Ex vrbe Die iij Iulij M.D.xvij

abcdefghijklmnopqrstuvwxyz

ABCDEFGHIJKLMNOPQ
RSTUVWXYZ

83 *Above left:* Lettering by Ann Hechle

84 *Below left:* An italic hand. Part of a letter to Cardinal Wolsey from Pasqual Spinula dated 6 August 1528. *Public Record Office* (SP 1/49, fol. 204)

85 *Above:* These are examples by John Lancaster of quickly written italic alphabets with a square pen and ink on ordinary typing paper

86 *Right:* Lively writing by Timothy Donaldson

5 Stanley Villas, Runcorn, Cheshire, WA7 4HW.

Dear Mr Lancaster, when I was first teaching myself calligraphy your book was one of those that I got from the Public Library, very good! Now I understand that you are looking for material for possible inclusion in your 2nd book. I send you a brush alphabet, I hope you like it if you want more – write me!

Yours Sincerely

Timothy Donaldson

The Rime of the ANCIENT MARINER

First published in Great Britain
in this Edition in 1972 by
The Arcadia Press,
38 George Street, London, W.1.

© 1972 The Arcadia Press

SBN 902745 02 6

Acknowledgements :
Mr. Philip H. Rowson for supplying the hand made 'Seaweed'
paper for the covers : The Wookey Hole Mill, Somerset, for
supplying the hand made 'Seaweed' paper for the text in co-operation
with Mr. Rowson : Wood Westworth & Co. Ltd., St. Helens,
for hand printing the text : Colour Workshop, Hertford, for
printing the illustrations : Grosvenor Chater, London, for
supplying the endpaper : Mackrell & Co, Witham,
for the brasses ; and Zachnsdorf Ltd., London, for the
hand binding .

Printed in Great Britain

87 Writing by David Howells from *The Rime of the Ancient Mariner* by Samuel Taylor Coleridge, published by Arcadia Press, 1972

88 *Below:* Poem by Stevie Smith written by John Poole

89 *Facing page:* Poem by Jean Yeomans written by John Lancaster

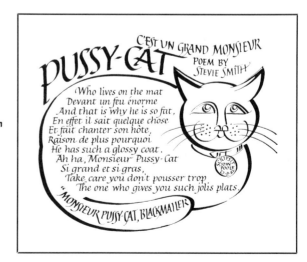

PUSSY-CAT C'EST UN GRAND MONSIEUR
POEM BY
STEVIE SMITH

Who lives on the mat
Devant un feu énorme
And that is why he is so fat,
En effet il sait quelque chose
Et fait chanter son hôte,
Raison de plus pourquoi
He has such a glossy coat.
Ah ha, Monsieur Pussy-Cat
Si grand et si gras,
Take care you don't pousser trop
The one who gives you such jolis plats.

"MONSIEUR PUSSY-CAT, BLACKMAILER"

To a house plant too long
without SUN

The stark
word
that is
dead
does not twigs
carry snap
the flavour : roots
 hang
 slack
the taste eaten
is of by darkness
soil :
closed veins
in plant
or man
do not
circulate
blood or light
 Jean Yeomans
 April 1975

John Lancaster scripsit 1981

71

90 Christmas greeting blocked in
gold and colour by David
Howells

91 Penmanship by Lilly Lee

92 *Above:* Exhibition notice written quickly with a quill then printed on card

93 *Right:* Calligraphy by John Lancaster

94 *Above:* Calligraphy by Miss S O'Sullivan, Bristol

95 *Right:* A thank-you note sent by John Lancaster to members of a research working party

The Celts emerged from central Europe, between 1000 and 500 B.C. They were a distinctive group of clans and tribes, with their own language, religion, society, and customs. Two divisions of Celts moved west to reach the British Isles. The Brython tribe, crossed the channel and established themselves in England and Wales. The Goidels, in the 4th Century B.C. passed directly from the Loire valley to Ireland.

The greatest symbols, of the ancient sacred tradition of magic and religion, created by the artistic Celts are the megalithic monuments, such as Stonehenge. The enormous standing bluestones are believed to have come from the Pembrokeshire Prescellis, and were moved to the Wiltshire site by "Giants who were magicians".

96 Detail from poster series designed and published by Workshop Wales. Copyright 1979

97 Formal lettering. Calligrapher not known

98 *Facing page:* Formal lettering by Ann Hechle

FRIENDSHIP

OH, THE COMFORT, the inexpressible comfort
of feeling safe with a person;
having neither to weigh thoughts nor measure words,
but pour them all out, just as they are,
chaff and grain together,
knowing that a faithful hand will take and sift them,
keep what is worth keeping,
and then with the breath of kindness, blow the rest away.

George Eliot

STRANGE TO BEHOLD
IS THE STONE OF THIS WALL
BROKEN BY FATE

THE STRONGHOLDS ARE BURSTEN
THE WORK OF GIANTS DECAYING
THE ROOFS ARE FALLEN
THE TOWERS ARE TOTTERING
MOULDERING PALACES ROOFLESS
WEATHER MARKED MASONRY
SHATTERING SHELTERS
TIME SCARRED TEMPEST MARRED
UNDERMINED OF OLD
EARTH'S GRASP HOLDETH
ITS MIGHTY BUILDERS
TUMBLED CRUMBLED
IN GRAVEL'S HARD GRIP
TILL A HUNDRED GENERATIONS
OF MEN PASS AWAY

BRIGHT WERE THE BUILDINGS
BATH HOUSES MANY
HIGH FOREST OF PINNACLES
WAR-CLANG FREQUENT MEAD-HALLS MANY
MERRIMENT FREQUENTING
TILL ALL WAS OVERWHELMED
BY FATE UNRELENTING
WHERE EREWHILE MANY A BARON
JOYOUS AND JEWELLED
WITH ELABORATE SPLENDOUR
HAUGHTY AND HOT WITH WINE
SHONE IN HIS HARNESS

75

Calligraphy '84

99 Heading by Stuart Barrie used on posters and as a catalogue title by the SSI. Stuart Barrie wrote the title several times with a *Witch* pen. He then selected the best one. This he covered with layout paper and rewrote the design again with speed over the image and did a little retouching

100 Personal book plate

101 *Below:* Personal book plate by David Howells

102 *Facing page, top left:* Semi-italic pen lettering employed on a printed soap wrapper. National Trust

103 *Facing page, centre left:* Thank-you note scribbled-off rapidly with a fibre-tipped pen

104 *Facing page, bottom left:* Double and single script – DEK – by John Lancaster

105 *Facing page, top right:* Printed script for company logo

106 *Facing page, bottom right:* Italic script by Aylwin Sampson, 1976 from *Saint David*, published by Yr Oriel Fach Press

Lavender soap
especially prepared
from the finest ingredients
for The National Trust

H.R.Higgins
(Coffee-man) Ltd.

In the 19th Century, soap cakes were hand cut &
sold by weight. This replica billet, after
milling, has been sliced and stamped
by hand whilst warm & pliable 100 g

The National Trust 42 Queen Anne's Gate
London SW1

The
National
Society
for Art
Education

Ymhen amser bu Dewi farw,
ar Fawrth 1af,
fe ddywedir

Ei eiriau olaf i'w Frodyr oeddynt,
"Parhewch yn y pethau hynny
a ddysgasoch
gennyf fi ac a welsoch
gennyf fi "

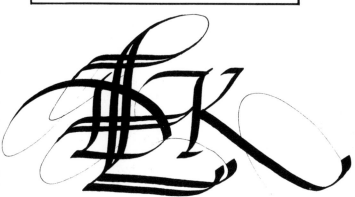

At length in the fullness of time
David died, on the 1 March
it was said.

His last words to his Brothers were,
"Persevere in those things
which you have learned
from me, and have seen
in me"

Restaurant
Beaudesert
· Henley · in · Arden ·

II.

abcdefghijklmnopqqrstuvxwyz

AN ITALIC HAND directly derived from the Foundational hand (I.) above.
The chief characteristics of the ITALIC Hands are 1 lateral compression, 2 branching
of the parts (n u &c) Secondary characteristics are 1. Elongated Stems, 2. a slight SLOPE
(This latter, probably the least essential, has been unduly exaggerated in modern use).

This example is made heavy to show the control of the pen (see General Note)
Various characters can be developed from it by (a) making lighter (b) making round
(c) lengthening stems (d) flourishing e.g. bdhklp (semi formal 16th cent
(e) coupling the letters (in less formal writing)

III.

abbcdefghijkllmnopq&

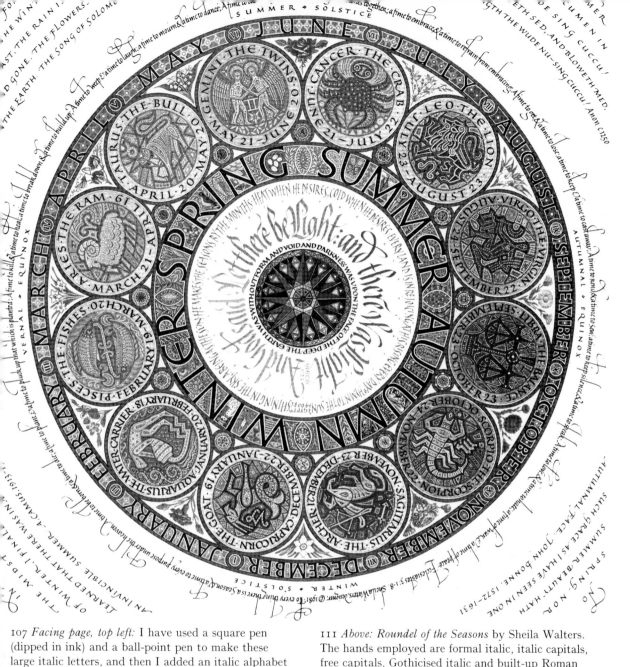

107 *Facing page, top left:* I have used a square pen (dipped in ink) and a ball-point pen to make these large italic letters, and then I added an italic alphabet for effect

108 *Centre left:* Restaurant logo

109 *Right:* Restaurant menu

110 *Bottom:* Slanted pen I Foundation hand II Italic hand III Roman small-letter hand. *Detail from plate 6, School Copies and Examples No 2, Pitman*

111 *Above: Roundel of the Seasons* by Sheila Walters. The hands employed are formal italic, italic capitals, free capitals, Gothicised italic and built-up Roman versals. The work, written and painted on calf vellum, was specifically designed for limited edition prints in the photographic medium of Cibachrome. *Cibaprint by Peter Waters, 1981*

112 *Overleaf:* A fine example of formal italic by Ann Hechle

Regular *pulse* *marked*

Before the beginning of years
There came to the making of man
Time, with a gift of tears
Grief, with a glass that ran

continuous base *Both are the same* Mozart's music and Swinburne's verses

3 3 3 3 recurring A rhythmic & reassuring pulse • on the heart beat • wh. underlies a poignant and disturbing theme

WHO
WHY
TOMORROW
WHO
Why
.but
can
Prime o
an
b

THE ANSWE
FOU
R

✕

Pleasure, with pain for leaven
Summer, with flowers that fell;
Remembrance fallen from heaven,
And madness risen from hell
Strength without hands to smite;
Love that endures for a breath:
Night, the shadow of light,
And life, the shadow of death.

pattern making

vvvvuuuuooooiiiaabcccdeeefffmssstu

IS THE SHIPWRACK THEN A STARTLE THE HARVEST

Sprung rhythm, the voice literally springs from stress to stress regardless of th

THE SOUR SCYTH
BLEAR
C

ding dong bell
pussy's in the well

There is a natural tendency in common speech
to perceive rhythm. The length of the spoken
syllables are thus adjusted to this end. This
is often echoed in Traditional Rhymes:

tond and strit

Iambic short, long pentameter five times

The quality of mercy is not strain'd
It droppeth as the gentle rain from heaven
Upon the place beneath : It is twice bless'd
It blesseth him that gives & him that takes
'Tis mightiest in the mightiest

V SAY
DAY

STERDAY ✗

Both are these same

BEFORE THE COCK CROW.

When Shakespeare & Bach have broken rhythm here it has served to underpin the meaning

ELL
ELL
et tempo changes

it becomes
The throned monarch better than his crown;
His sceptre shows the force of temporal power
The attribute of awe & majesty,
Wherein doth sit the dread & fear of kings:
But mercy is above this sceptred sway
It is enthroned in the hearts of kings
It is an attribute of God himself
And earthly power doth then show likest God's
When mercy seasons justice

ERE

becomes rhythm

hyytttturhykllmiiiooopqrhythmm

SHEEP BACK
TEMPEST CARRY THE GRAIN FOR THEE ?
of words or syllables. Consider these two equivalent lines from the same poem
NGE AND THE
RE

dark, dark, dark
they all go into the dark

Yet another way of controlling rhythm is by
recognising where the inherent length of the
word MUST set the pace. In the above phrase
it is impossible to say those words quickly:

7
DESIGN AND LAYOUT

There are now many books on the market devoted to the subject of lettering and calligraphy and most of them have one thing in common – they stress book design and page layout which have a traditional foundation. There is nothing wrong with tradition, of course, and the highlighting of these approaches is obviously a real necessity for both amateur and professional calligraphers, for it re-stresses the long held, basic mechanics of the craft.

1 THE BOOK

Most fundamental ideas and rules, particularly with respect to the planning and layout of manuscript books, emanate from medieval concepts employed by scribes and illuminators who worked in the many cathedrals, monasteries and abbeys scattered throughout Europe. Their scriptoria were what I would call the 'communication centres' of their times. They were busy workshop/studios which, through their book art, equated to our own mass media services today. (Figures 113 and 114.)

Manuscript design and layout varied little from scriptorium to scriptorium, and from century to century but it did leave its indelible mark upon the design of printed books. It may be equated to the engineer's blueprint or the architect's sketch and results from well-founded practice, but it also points to a craft which had tended to be restricted by somewhat narrowly prescribed rules. This is a pity for, as an art form, calligraphy should lend itself to artistic invention, interpretation and new visual stimulus so that its own graphicacy is constantly refreshed. Throughout the middle ages artistry of every kind was dominated by the Church. The cathedral was a splendid art gallery which was alive with medieval sculptures, stained glass pictures, paintings, frescoes, tapestries, patterned floor tiles, richly-embroidered vestments, silverware, carved inscriptions and richly-decorated manuscripts. Even the tiniest rural church acted in a similar capacity so that things of beauty could be enjoyed by the literate worshippers, illiterate peasants and gentry alike.

Book art embraces both written and illustrative forms of communication as well as presenting fine, jewel-enriched bindings. Such communica-

113 *Facing page, top:* Page opening of a thirteenth century French illuminated psalter in the Romanesque tradition. MS 10607 ff 149v and 150R 245 folios. *The Department of Manuscripts, the Royal Library of Belgium*

114 *Facing page, bottom:* Page opening from a thirteenth century Koran showing that book design as we know it was not simply confined to Europe. OR 1009f 115v–116R. *Reproduced by permission of the British Library*

82

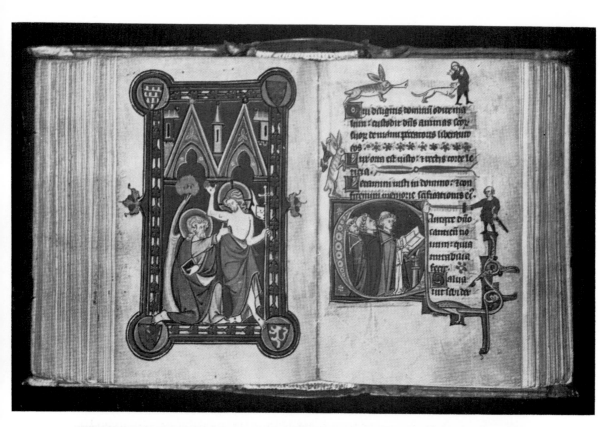

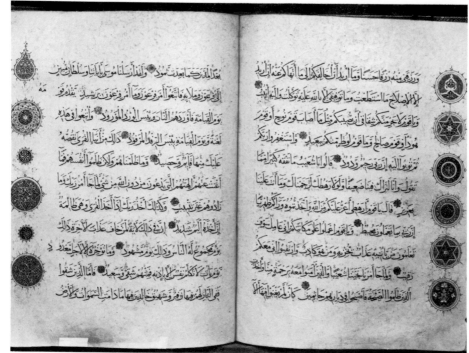

83

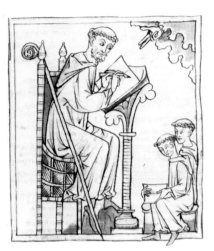

115 Thirteenth century scribe writing. MS Laud Misc 385 Fol 41v (Flores Bernadi). *Reproduced by permission of the Bodleian Library, Oxford*

tion has to a large extent been overtaken by today's mass media – with advertising, glossy magazines, film, television and computer-aided technology adding further dimensions – in contrast to the much more leisurely approach of the medieval scribe. The modern world is activated by speed and rapid distribution, whereas in earlier ages personal commitment over long periods was important. Craftsmanship depended upon a highly developed technical accomplishment in what would seem to us to be an agonisingly slow production of works of art: artistic endeavours which reflected a much more gentle pace of everyday living. The medieval calligrapher had few distractions and could concentrate upon his work. He lived and worked in the sheltered confines of religious communities whose prime aim was a devotion to the service of God. His lifestyle was regulated by a simple, daily pattern from which it was virtually impossible for him to deviate.

The designing of pages of vellum for inclusion in manuscripts was, then, a regulated matter. It followed the dictates of specific cultural styles associated with religious and scholastic centres and was governed by a few basic rules. These were seldom questioned, unlike the questioning attitudes which have proliferated in Western society throughout the twentieth century. The calligrapher was not an innovator. Rather he was, as often as not, a mechanical robot capable of producing endless lines of crisply formed script letters, much as the office typist will do today. His was 'hack work', produced with quill, ink and vellum, and it relied upon an acquired skill. It was, nevertheless unlike office typing, an artistic skill, and as a member of a team of scribes and illuminators he might:

- only be responsible for the preparation of parchments on which others would work
- prepare his own vellum as a scribe
- be involved in lining up pages for manuscripts which others would write
- line up his own pages
- be involved in the writing of large tracts of text with black ink
- simply be a rubricator
- draw and paint miniatures on pages which had already been written by others
- simply do gilding: ie raised gold letters, marginal decorations, or the 'illuminating' of miniature paintings
- or, if he were a really gifted artist, he might even do all of these aspects.

The medieval scriptorium was a kind of factory employing a production-line approach to ensure maximum output. A great deal of copying went on in such a studio: the copying of bibles, psalters and books loaned from other religious institutions or their libraries, although original work was also produced by the scribes.

A scriptorium was a special place in a medieval religious community and Adso of Melk, a fourteenth century monk, provides us with a vivid picture of the scriptorium in an Italian abbey situated in the Appenines in

the region between Piedmont, Liguria and France. The year was 1327. Adso was a young novice and he was overawed by his first glimpses of this special workshop where he met many *scholars, copyists* and *rubricators.* The scriptorium was situated in the Aedificium, a large octagonal tower, and was approached by a flight of steps. Adso was accompanying his master, a learned Franciscan called Brother William of Baskerville. He writes:

'When we reached the top of the stairs, we went through the north tower into the scriptorium, and there I could not suppress a cry of wonder. This floor was not divided in two like the one below, and therefore it appeared to my eyes in all its spacious immensity. The ceilings, curved and not too high (lower than in a church, but still higher than in any chapter house I ever saw), supported by sturdy pillars, enclosed a space suffused with the most beautiful light, because three enormous windows pierced each of the five external sides of each tower; eight high, narrow windows, finally, allowed light to enter from the octagonal well.

'The abundance of windows meant that the great room was cheered by a constant diffused light, even on a winter afternoon. The panes were not coloured like church windows, and the lead-framed squares of clear glass allowed the light to enter in the purest possible fashion, not modulated by human art, and thus to serve its purpose, which was to illuminate the work of reading and writing.

'As it appeared to my eyes, at that afternoon hour, it seemed to me a joyous workshop of learning. . . . Antiquarians, librarians, rubricators, and scholars were seated, each at his own desk, and there was a desk under each of the windows. And since there were forty windows, forty monks could work at the same time. (These monks were exempted from the offices of terce, sext, and nones, so they would not have to leave their work during the hours of daylight.)

'The brightest places were reserved for the antiquarians, the most expert illuminators, and rubricators, and the copyists. Each desk had everything required for illuminating and copying: *inkhorns, fine quills* which some monks were sharpening with a thin knife, *pumice stone* for smoothing the *parchment, rulers* for drawing the lines that writing would follow. Next to each scribe, or at the top of the *sloping desk*, there was a lectern, on which the codex to be copied was placed, *the page covered by a sheet with a cut-out window* which framed the line being copied at the moment. And some had *inks of gold and various colours.*'

They went across to one of the monk's desks, and Adso continues:

'We approached what had been Adelmos' working place, where the pages of a richly illuminated psalter lay. They were folios of the finest vellum – that queen of parchments – and the last was still fixed to the desk. Just scraped with pumice stone and softened with chalk,

it had been smoothed with the plane, and, from the tiny holes made at the side with a fine stylus, all the lines that were to have guided the artist's hand had been traced. The first half had been covered with writing, and the monk had begun to sketch the illustrations in the margins. The other pages, on the contrary, were already finished, and as we looked at them, neither I nor William could suppress a cry of wonder.'

The incredible amount of artistic labour which went into the production of manuscripts is shown to us later by Adso, who spent a great deal of time in subsequent years working as a scribe, and the strain this had on the artist. He goes on:

'I know what torment it is for the scribe, the rubricator, the scholar to spend the long winter hours at his desk, his fingers numb around the stylus (when even in a normal temperature, after six hours of writing, the fingers are seized by the terrible monk's cramp and the thumb aches as if it had been trodden on). And this explains why we often find in the margins of a manuscript phrases left by the scribe as a testimony to his suffering (and of his impatience), such as "Thank God it will soon be dark," or "Oh, if I had a good glass of wine," or also "Today it is cold, the light is dim, this vellum is hairy, something is wrong". As an ancient proverb says, three fingers hold the pen, but the whole body works. And aches.'

(Excerpts from *The Name of the Rose* by Umberto Eco, from the Italian by William Weaver, Secker and Warburg, London 1983.)

Many of the scriptoria must have been similar to the one Adso describes. They must have been fascinating places in which history was recorded and made.

PLANNING A BOOK

The earliest forms of manuscript books, as we know them now, can be traced back to the first century AD (ref: E M Thompson, 1912 *Introduction to Greek and Latin Paleography*, Clarendon Press, Oxford), when tablets of wax were hinged together to form what we would call page openings. Roman scribes had previously written *square capitals* on rolls of vellum or

116 Square capitals

papyrus which emanated from Egypt and Greece. But rolls made it difficult to search out particular references and so the idea of the flat page or book opening was an innovation which could, in essence, be equated, as a technological advance, to the computer floppy disc. It gave the scribes an opportunity to write on both sides of the vellum, resulting in a saving of precious material and space, and meant that the book could be used as a more easily transportable and useful object. Writing speeds were also increasing due to the more widespread adoption of the easier *rustic scripts* which gradually took over from the more cumbersome formal styles which preceded them.

ABEDM

117 Rustic letters

118 Double page from a Book of Hours executed about AD 1300 in or near Maastricht in which the marginal lines are clear to see. Stowe MS 17 ff 243b–244. *Reproduced by permission of The British Library*

So the medieval manuscript developed. It consisted of a number of quires of vellum – the term *quire* referring to four sheets folded 'quaterino' – with each quire containing eight leaves or pages. A manuscript developed on these lines became known as a *quarto book*, whose proportions and layout are useful starting points for ourselves.

We would normally use paper when planning a book. However, if vellum is to be employed then it is wise, for the sake of colour and surface texture consistency, to arrange the prepared sheets of skin so that hair side faces hair side.

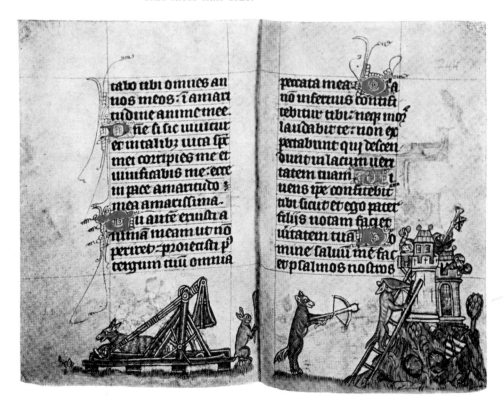

The sizes and shapes of books vary greatly, depending upon the purpose to which they are to be put. Some may be squarish in shape, others tall and narrow, while some will be long and slim. Whatever size and shape you decide to use it would be sensible to adopt a simple marginal layout or plan. The proportion of the writing areas to the overall shape and size of the page is important and thought will therefore have to be given to the appropriate widths of the margins at the top, sides and bottom of the page. Once these have been determined then all the pages in the book should conform to the plan.

A simple guide is to consider a *quarto* book page opening. This will consist of *five* margins – *two* horizontal margins (one at the top and the other at the bottom of the page) and *three* vertical margins (one at each side and one in the centre where the page opening folds and will be stitched). The proportions of these margins may vary for there is no hard and fast rule. The following *proportions* offer a useful guide:

Top margin	(2)	= half the width of the bottom margin
		= smaller than each of the vertical margins
Bottom margin	(4)	= twice the width of the top margin
		= larger than each of the vertical margins
Vertical margins		= all of equal size
($1\frac{1}{2}$ each)		= wider than the top margin
		= not as great as the bottom margin

119 Double page layout based upon traditional manuscript margins and their proportions. These may be varied according to the type and shape of book

120 A verse from a fifteenth century carol *O, Flos de Jesse*, written by Thomas W Swindlehurst on vellum in black ink with title in gold

121 *Facing page, top:* Opening written by E M Ridlington from The First Epistle of St Paul to the Corinthians. A small manuscript book on paper, on which John Lancaster has indicated marginal lines

122 *Facing page, bottom:* Detail for opening page in Welsh and English from a *Church in Wales* by Aylwin Sampson, 1976, published by Yr Oriel Fach Press

swallowed up in victory. O death, where is thy victory? O death, where is thy sting? The sting of death is sin: and the power of sin is the law: but thanks be to God, which giveth us the victory through our Lord Jesus Christ. Wherefore, my brethren, be ye stedfast, unmoveable, always abounding in the work

of the Lord, forasmuch as ye know that your labour is not vain in the Lord.

Chap: XVI Now concerning the collection for the saints, as I gave order to the churches of Galatia, so also do ye. Upon the first day of the week let each one of you lay by him in store, as he may prosper, that no collections be made when I come. And when

Y MDDANGOSODD angel mewn breuddwyd i Sant, mab y brenin Ceredig, un o feibion Cunedda Wledig - daethent hwy o'r Gogledd i erlid y Gwyddelod o'r wlad.

Dywedodd yr angel wrth Sant y cai ef trannoeth wrth hela ger afon Teifi dair arwydd y genid mab ymhen deng mlynedd ar hugain: carw [credid bod ceirw a hyddod yn bwyta nadredd - symbol o fuddugoliaeth y Cristion ar y Sarff], pysgodyn [a gynrychiolai ymgadw rhag pob diod ond dŵr], a gwenyn [doethineb].

Aeth negesydd nefol arall at Padrig Sant yn ei gymuned Gristionogol yn y Tŷ Gwyn, ger Carn Llidi, i ddweud wrtho am y geni i ddod, a gorchymyn iddo ymwrthod â'i fwriad i symud i Lyn Rhosin - lle mae'r eglwys gadeiriol heddiw - am mai yno y sefydlid mynachlog Dewi yn y dyfodol.

A N ANGEL appeared in a dream to Sant, son of King Ceredig, who was one of the sons of Cunedda Wledig - they had come from the North to drive out the Irish settlers.

The angel told Sant that next day whilst hunting by the river Teifi he would find three tokens of the son who would be born to him in thirty years time: a stag [it was believed that stags and harts ate snakes - so symbolizing Christian victory over the Serpent], a fish [representing abstinence from all drink but water], and bees [wisdom].

Another heavenly messenger went to St Patrick at his little Christian community at Ty Gwyn, by Carn Llidi, to tell him of the future birth, and also to command him to give up his plan to move to Glyn Rhosyn - where the cathedral now stands - as that site was reserved for David and his monastery.

GREETINGS

WHEREAS on the 7th day of June, 1945, the Lord Mayor, Aldermen and Citizens of the City and County Borough of Leeds did confer upon the King's Own Yorkshire Light Infantry the right, liberty and privilege of marching through the streets of Leeds on all ceremonial occasions with bayonets fixed, bands playing, drums beating and colours flying,

2 THE ILLUMINATED ADDRESS

Formal illuminated addresses are normally designed as 'broadsides' so that they can be framed and hung like pictures. They are often in the form of loyal addresses or scrolls, comprising areas of formally-written script which are juxtaposed with heraldry (coats of arms, shields, etc), seals and decorative ribbon. They will be designed either as 'portrait' (vertical pieces) or 'landscape' (horizontal pieces), and will often be completed in black ink, gold, silver and colour.

The easiest way to plan an illuminated address or scroll is to consider it as a rectangle or, more unusually, as a square and to *centre* the design on a central axis. The lines of pen lettering will normally be centred so that an irregular margin results at each side, and illuminated, decorated features will also be centred in appropriate positions.

Some craftsmen find it difficult to 'centre' lines of script and should find the following directions of help (ref: *Lettering Techniques* by John Lancaster, Batsford 1980 and 1982):

1 It is assumed that the size, shape and design of the work has been decided, including the style of script and decoration.
2 Prepare 'rough' designs.
3 Prepare a 'draft' layout to the exact size of the work in hand. (Sheet A)
4 Rule this up with a pencil or fine bone point and do the same with the piece of 'stretched' vellum or hand-made paper for the final version, including a faint *centre line*.
5 Rule up a third sheet of paper – with no vertical centre line but with a vertical margin line to the left only – on which to write your first draft. (Sheet B)
6 On this paper you can now write with appropriate pens (quills, steel nibs or reeds) the various titles, subtitles and lines of script starting each one at the left-hand margin. This will give you an idea of the length of each line and will enable you to make small adjustments. Number each line of script very lightly in pencil on the left-hand side of the sheet and do the same on Sheet A and the final vellum or paper.
7 The lines of script on Sheet B are now cut out in the form of long, slim slips, and each one is folded so that the first letter on the line corresponds with the last letter on the line. Mark the fold with a clear pencil mark.
8 Take strip No 1 (line 1) and place it on line 1 of your draft (Sheet A), with the centre fold on the centre line. Mark off the length of this line of script. Do this for every line.

123 Detail from an Illuminated Address on vellum by E John Milton-Smith

124 An Illuminated broadside by the author in gold and egg-tempera colours on vellum

125 Two Illuminated Freedom Scrolls by **E** John Milton-Smith

3 POETRY

The modern calligrapher can be more inventive when he designs pages of
poetry. He is able to contrast the weight of the text to the titlings and he
can add decorative or coloured letters at the beginnings of the lines.

Once again it is possible to employ a 'centering' layout as in the poem by
W M Gardner. This scribe has written a type of pointed italic in black,
with the title and first letters of each line in red.

Although Edward Johnston hasn't written a poem here, it is a fine
example of well thought out design. Here again the text is in a pointed
italic (black) with the title and right-hand marginal writings in vermilion.

126 Calligraphy by W M
Gardner in red and black

127 *Facing page:* Calligraphy by
Edward Johnston. *Sayings of
Artists on Art,* 1926. *Property of
St Kelda Art Gallery, Melbourne,
Australia*

4 GENERAL LAYOUT

Calligraphers, as designers, are often asked to produce notices, posters, letterheads, cards, title pages, etc, and find themselves in a position to be experimental. They can use large, bold letter forms, illustrative materials, colour and pattern. The main thing is to be clear so that the design itself presents or communicates its message. Here are a few examples.

Sayings of Artists on Art.

AS I CAN.

Device {ALC: IXH· XAN·} of Jan Van Eyck c.1585-1441.

Thou, O God, dost sell unto us all good things at the price of labour. Leonardo da Vinci 1452-1519.

The gathered secret treasure of the heart is manifested by the work, and the new creation which a man createth in his heart appeareth in the form of a thing. Durer 1471-1528.

Good painting is a music and a melody which Mind only can appreciate. Michelangelo 1475-1564.

Let it be enough that you can put into practice that which you know, then, in good time, the hidden meaning will discover itself Rembrandt van Ryn 1606-1669.

Ideal perfection and beauty are not to be sought in the heavens, but upon the earth. They are about us and upon every side of us. Reynolds 1723-1792.

A picture the effect of which is true is finished. 1746-1828. Goya y Lucientes

Painting as well as poetry and music exists and exults in immortal thought. Blake 1757-1827.

Nothing but a close and continual observance of nature can protect them [painters] from the dangers of becoming mannerists. Constable 1776-1837.

An artist must himself first be moved if he is to move others. Millet 1814-1875.

When the operation of the spirit is weak, all forms are defective, and though the brush be active its productions are like dead things. Ching Hao Chinese Artist, 10th. Century.

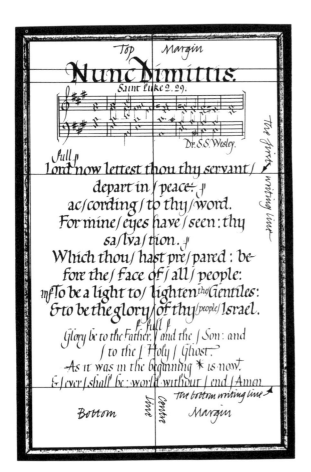

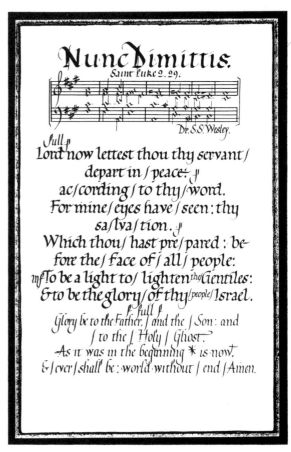

128 The *Nunc Dimittis*. A simple broadside written in black ink, blue and orange vermilion on sheepskin by John Lancaster when a student. It indicates the basic design and marginal lines and demonstrates a 'centering' technique which is often appropriate for the writing of poetry

129 Cover for students notes. University of Bristol

130 Calligraphy by Lilly Lee

CRAS
AMET
QUI
NUN=
QUAM
AMA
VIT
QUI=
QUE
AMA
VIT
CRAS
AMET

TOMOR
ROW
MAY HE
LOVE

WHO
NEVER
LOVED
BEFORE

AND
MAY
HE
WHO

HAS
LOVED
LOVE
TOO.

who never loved before and may he who has loved love too· SCRIPSIT·LILLY LEE 1981 · mavit cras amavit

nunquam amavit quique ··· cras amavit qui·· THE NIGHT WATCH OF VENUS··· tomorrow may he love···who

131 Letter heading designed by
John Woodcock

132 This was designed by John
Woodcock as a 'mark', rather
than as a logo, for publicity for
the 1981 SSI exhibition. The
intention was speedily to
indicate calligraphy rather than
to be legible lettering – hence
the 'broken' forms of letters.
Height about 250 mm on posters

133 An adaptation from the
above publicity

134 to 136 *Facing page:* Posters
and notices written by John
Poole

hi kids & welcome to BENTWATERS OFFICERS' CLUB
Special portions for those under 12 or over 65

#1. THE SHERIFF OF NOTTINGHAM'S SUPPER
2 Small Pieces Crispy Fried Chicken
Choice of Potato
Vegetable
Rolls and Butter
Milk or Tea

#2. MAID MARION'S DELITE
Peanut Butter and Jelly Sandwich
Potato Chips
Milk or Tea

#3. LITTLE JOHN'S DINNER
Juicy Chopped Sirloin Steak
Choice of Potato
Vegetable
Rolls and Butter
Milk or Tea

#4. FRIAR TUCK'S SPECIAL
Fish Fingers
Choice of Potato
Vegetable
Rolls and Butter
Milk or Tea

#5. PRINCE JOHN'S TREAT
Juicy Junior Burger with Trimmings
Choice of Potato
Milk or Tea
With Cheese

#6. ROBIN HOOD'S FAVORITE
Tasty Pork Chop with Apple Sauce
Choice of Potato
Vegetable
Rolls and Butter
Milk or Tea

#7. THE SHERWOOD FOREST SPECIAL
Spaghetti Loops in Cheese Sauce
Buttered Toast
Vegetable
Milk or Tea

SALAD BAR is not included

THE GROVE SINGERS
DIRECTOR MICHAEL WRIGHT WITH
MICHAEL ILLMAN ORGAN AND TONI WOODROW READER

CHRISTMAS CONCERT
AT ST. ANDREWS CHURCH, FELIXSTOWE
ON SATURDAY, DECEMBER 17th
AT 7·45 PM ADMISSION BY
PROGRAMME £1

137 Cover of brochure written
by Derek Schofield, Head of
Graphics, Manchester
Polytechnic

138 Exhibition notice

139 *Facing page:* Exhibition
notice written by Ann Hechle

ART EXHIBITION
FRIDAY x SATURDAY · NOVEMBER 23 x 24 '84

On behalf of the Wick Foundation
Gill x Christopher David
and Hilary x Nicholas Chiswell Jones
are holding an Exhibition of

PORCELAIN x STONEWARE
PAINTINGS · ETCHINGS
x SCULPTURE ·

by prominent and
internationally known artists:
at WICK COURT
WICK · BRISTOL

(Abson 3440)

We would like to invite you to a
PREVIEW
on Thursday · November 22nd
Between 7 pm · 10
Wine x Light Refreshments

Commissions on sales will go to a new
all weather play area for the Wick Court Centre

PLEASE BRING THIS INVITATION WITH YOU

5 LETTER WRITING

A well-designed and nicely written letter is always a pleasure to write and certainly a joy to receive. I know at once when I get a well-written envelope through my letterbox that the contents will be visually exciting. What is more, the address on the envelope will be pleasurable to the postman and help to brighten up his day. This, in itself, must be a good thing and therefore worth doing.

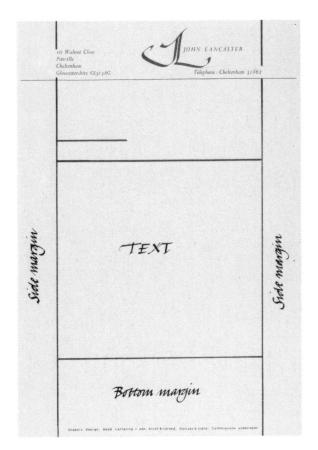

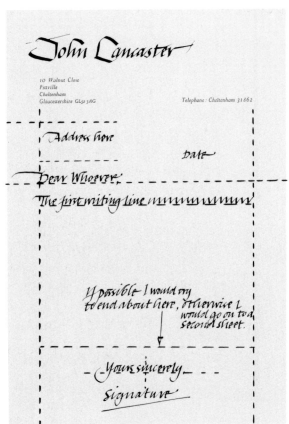

140 Letter writing

141 Letter writing

Facing page
142 *Top left:* Formal letterhead designed by John Lancaster for a large secondary school in Yorkshire
143 *Top right:* Personal stationery designed by Jean Larcher
144 *Bottom:* Letter to John Lancaster for Thomas W Swindlehurst, 1955

Don Valley High School

Scawthorpe, Doncaster · Phone 3241

Jean Larcher
16 Chemin des Bourgognes 95000 Cergy,

LEEDS COLLEGE OF ART
Principal E. E. Pullée, A.R.C.A. F.S.A.E.
VERNON STREET LEEDS 2

Telephone 31027/8

1st December 1955

Dear John,

Thank you for your letter.
Sorry there has been this delay
in my reply.
I am sending herewith a
testimonial as you request.
which I trust is adequate for
your requirements.
Having a busy time and the
students having their end of
term examinations.
Trust you are well,
All good wishes
Yours sincerely
Thomas W. Swindlehurst.

THE LETTER

Letterheads may be written by hand or printed. If they are designed well they set the tone for the contents, which should relate to them – in a design sense – so that margins correspond and make it easy to read what the letter has to say. The only rule to follow is that the top and side margins are generally the same, while the bottom margin is a little larger.

On my own headed paper I tend to allow the margins at each side to drop down from the left-hand side of the printed address (left side) and the figure 2 at the end of my telephone number (right side).

THE ENVELOPE

145 Letter to John Lancaster from Eric Brocklehurst, 1981

146 Notes from Eric Brocklehurst, 1981

An envelope addressed well will be easy for the postman to handle. There should be plenty of space on the left-hand side for him to grip the envelope without obscuring the address and so the writing (or typing) of the address should start approximately one third of the way in. The writing line should start approximately half way down, leaving plenty of space above for the postage stamp and franking marks.

145 Letter to John Lancaster from Eric Brocklehurst, 1981

146 Notes from Eric Brocklehurst, 1981

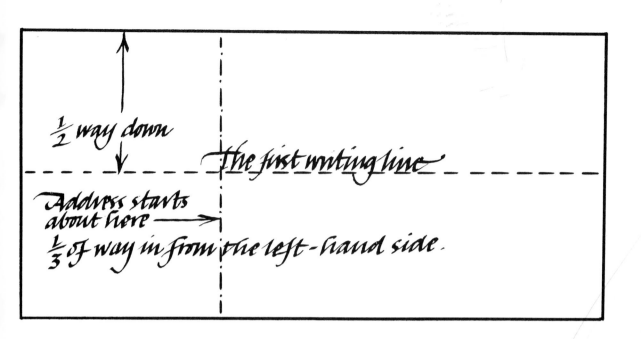

LEEDS COLLEGE OF ART

John Lancaster Esq., A·T·D.
14, Lyndhurst Road,
Hollins,
OLDHAM.

147 Addressing an envelope

148 Envelope addressed by Thomas W Swindlehurst, 1955

J. Lancaster. Esq
10, Walnut Close,
Pittville,
Cheltenham,
Gloucestershire.

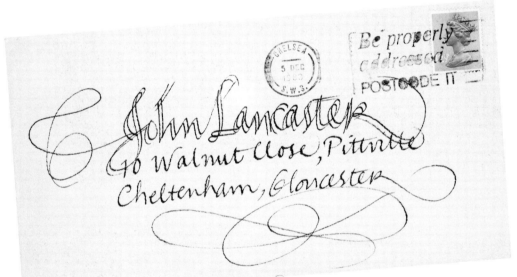

John Lancaster
40 Walnut Close, Pittville
Cheltenham, Gloucester

John Lancaster. Esq.,
School of Teacher Training,
College of Art, Newarke,
LEICESTER.

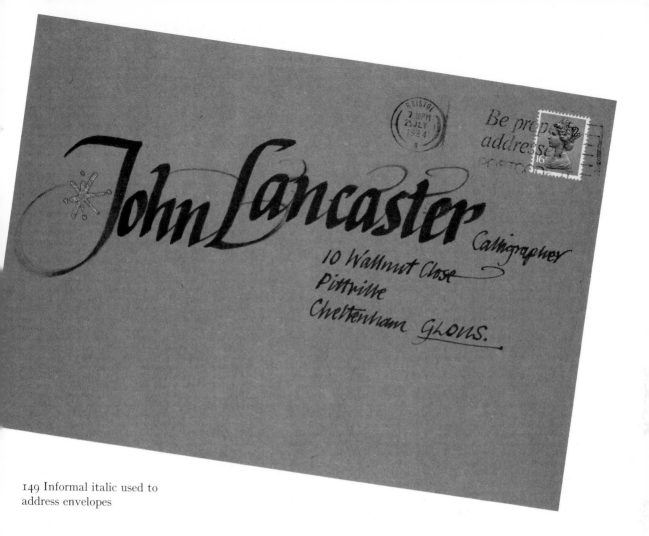

149 Informal italic used to
address envelopes

8
EXPERIMENTAL APPROACHES

Traditional skills and techniques are important to any craft for they provide a sound base for those who pursue it. It is important, however, that the craft itself should move gently forward as ideas, materials and techniques evolve. Just as the early scratchings in stone and the paintings on cave walls – which provide us with a record of the art and communication skills of primitive peoples – developed into the art of making lettering on wax tablets with a stylus, on papyrus with a reed pen and then on animal skins and paper with a quill, so too must letterers and calligraphers today seek to put new visual excitements into their work.

Calligraphy would be very dull and uninteresting if it was manifested solely in traditionally-based methods, especially in this computer-image age, and I would urge you to attempt to be inventive. It is exciting to think and plan different arrangements. You could also get right away from the square-ended pen, paper, card or vellum, if you wish, for many new materials exist for experimentation.

SOME STARTING POINTS

Here I propose to introduce you to a number of ideas. I shall show you a starting point from which I developed two, three or more stages in producing a final image. You may wish to do the same. In fact there is no harm in simply copying what I have done so that you will gain confidence. Then, of course, you must attempt to do some original pieces of work, using your personal gift of inventiveness. Here are some starting points:

- a *point* (dot) – from which to radiate pen-made forms
- a *circle* – within which to write the letters of the alphabet
- a *circle* – around which to write letters or words
- a *square*
- an *irregular geometric shape*
- an *oval shape*

EXPERIMENT and think of other shapes for yourself.

In all the examples which follow I worked on sheets of A4 typing paper. I drew the geometric shapes with a black felt-tipped pen and used two sizes of quills for the scripts.

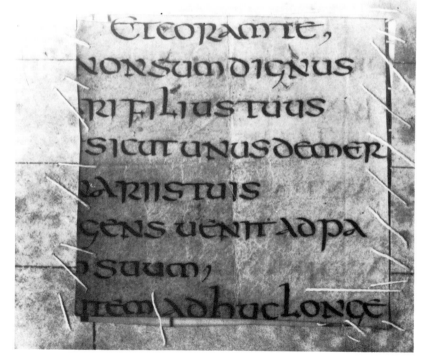

150 Egyptian wax diptych of the second century BC which was a typical and convenient method of communication before the advent of the quarto book. Bodleian Library, Oxford, MS Lat. class f 10 (P)

151 Uncial lettering of the seventh and eight century from Italy. CLA 11 145 done with a quill on vellum. Poole MS 65 seventh and eighth centuries, Italian. Bond and Fay Supplement to the *De Ricci Census*, 1962, pages 182–183, Bodleian Library, Oxford, CLA 11 145 uncial, *Reproduced by courtesy of the Lilley Library, Indiana University, USA*

EXAMPLE 1 *Alphabets radiating from a point*
STAGE 1 I placed a point (a dot) in the very centre of the paper and drew ten lines which radiated from it. (Figure 152.)
STAGE 2 I now began to write alphabets from the centre point and along the radiating lines towards the edges of the paper. This can be seen clearly in figure 153, which I deliberately left unfinished in order that the directional lines (dotted) are visible.

152

153

EXAMPLE 2 *Alphabets based upon a 5-sided shape* (a *pentagon*)
STAGE 1 This 5-sided geometric shape was drawn at a randomly-chosen place on the paper. (Figure 154.)
STAGE 2 Two alphabets were written, the one with the broader quill actually along the sides of the 5-sided shape, with the smaller alphabet simply following one of the sides of this shape (figure 155), using the drawing of the shape as a template, which I had placed underneath the writing surface.
In figure 156 I have drawn in the directional lines of the original shape simply for your information.
When I work on ideas such as this I do not draw guidelines for I prefer to work in a free-hand manner.

Overleaf
EXAMPLE 3 *Using a circle*
Here we see five stages in which a circle is the
foundation for the designed image.
(Figures 157 to 161.)

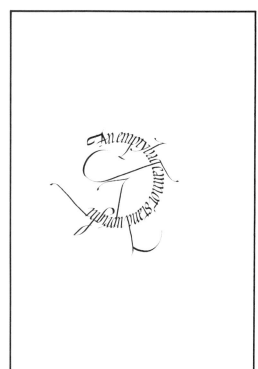

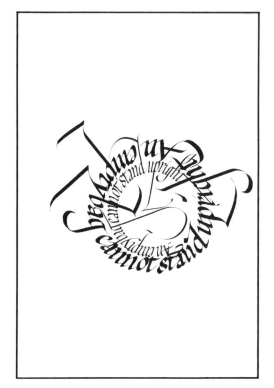

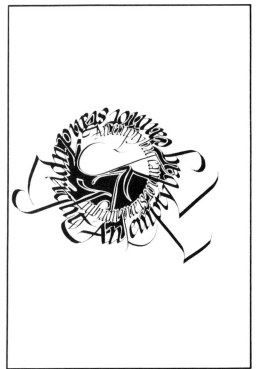

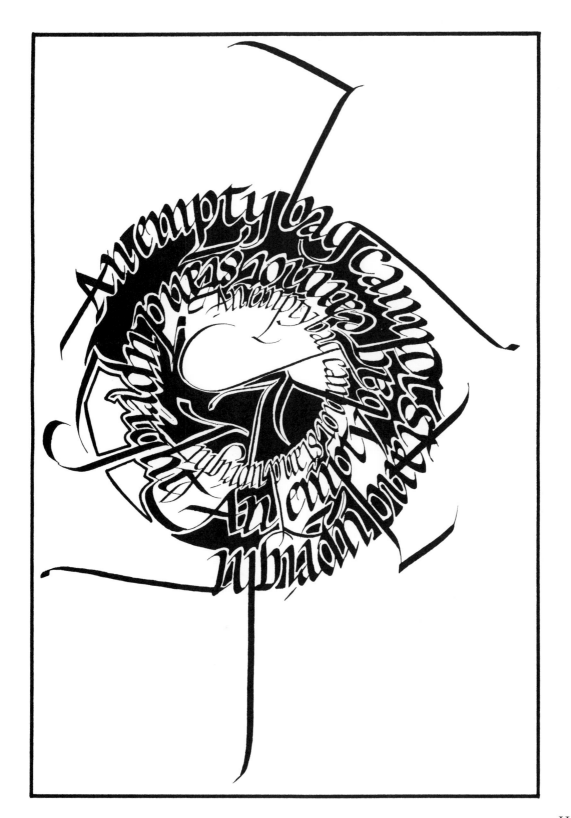

162

EXAMPLE 4 *Starting with an oval*
Before we go on to this design I should like to assure you that in doing the calligraphy for this section I used basic materials which are readily available, ie typing paper, black 'Quink' fountain pen ink, a ruler, a pencil and a quill. Instead of the quill I could have used a metal nib or an *Edding* 'Calligraphy' fibre-tipped pen or a *Berol* 'Italic Pen'.

In this example I reverted to a basic alphabet.

STAGE I I drew the oval, as shown in figure 162, with a black felt-tipped pen around a card template. This oval shaped card was an off-cut which my picture framer gave me.

163

164

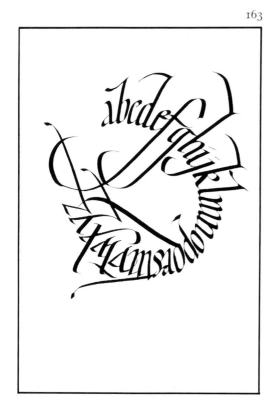

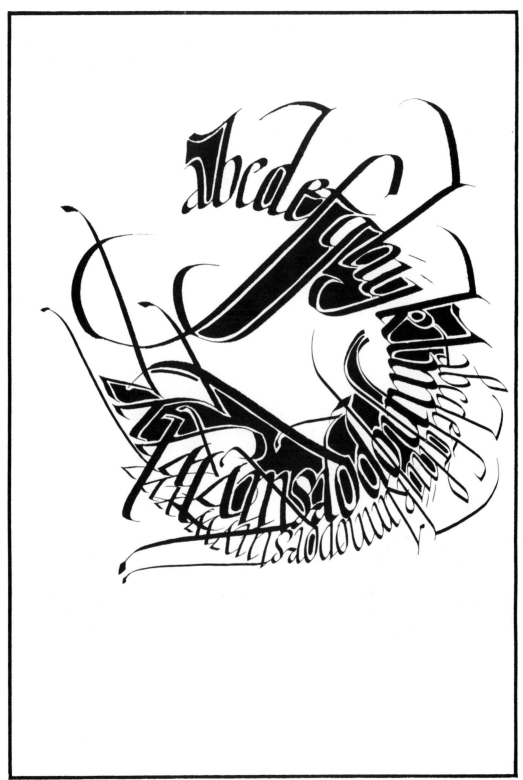

166

STAGE 2 Following earlier procedures I wrote this formal Italic alphabet around the oval shape. (Figure 163.)

STAGE 3 A much more spidery alphabet was then penned along and outside of the first one. (Figure 164.)

STAGE 4 Areas between the letter shapes were selected and filled in with colour, much as the scribes and illuminators who had worked on the *Book of Kells* must have done with some of their decorated letters in the eighth century. (Figure 165.)

This method of working should now be clear and so I should simply like to draw your attention to other imagery which has been developed from the same or similar sources.

(A) 'If you have time don't wait for time'
A phrase which lent itself well to a 5-sided shape. (Figures 166 to 169.)

(B) 'An empty bag cannot stand'
A slightly different version of the circle design produced in EXAMPLE 3. This one started off with the same circle, the first two written phrases and then developed quite differently. (Figures 170 to 172.)

167

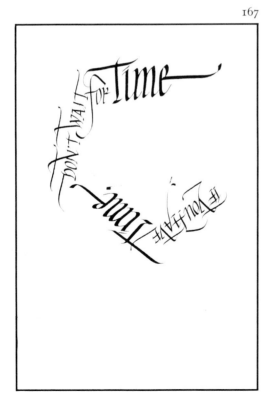

168

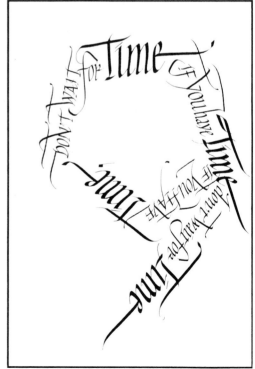

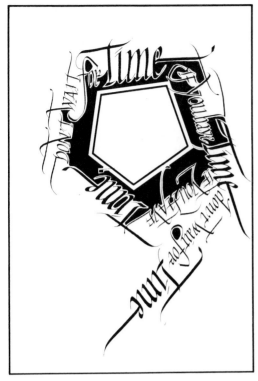

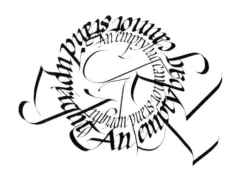

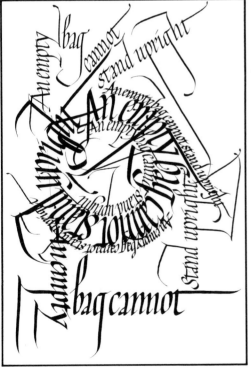

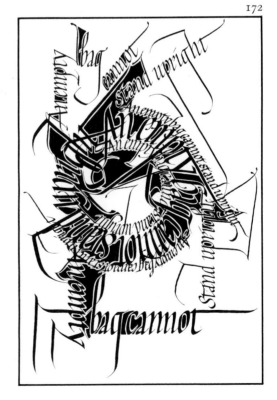

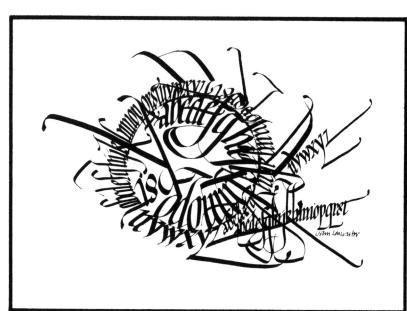

173

174

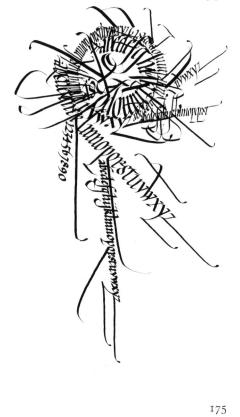

175

176

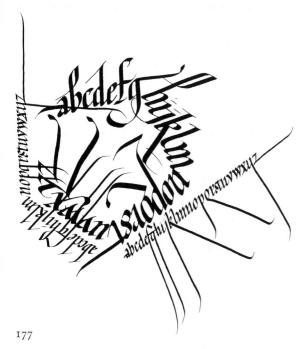

177

178

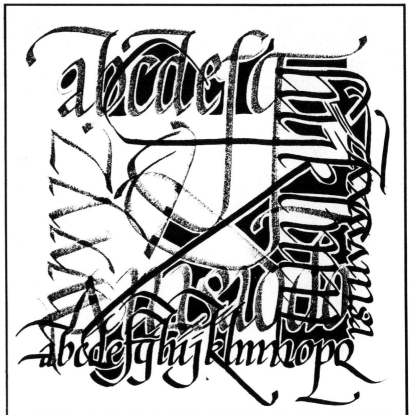

179

173 Student work – a large oil painting based upon script lettering in which an experimental and inventive approach has created a lively, abstract work

174 Calligraphic alphabet originating with a circle written by John Lancaster

175 The original 'circle' image developed differently

176 The imagery developed

177 Variation

178 Variation

179 Freely written alphabets in fibre-tipped and metal nibs arranged around a square

Great peace have they
that love Thy Law
and nothing shall
offend them.

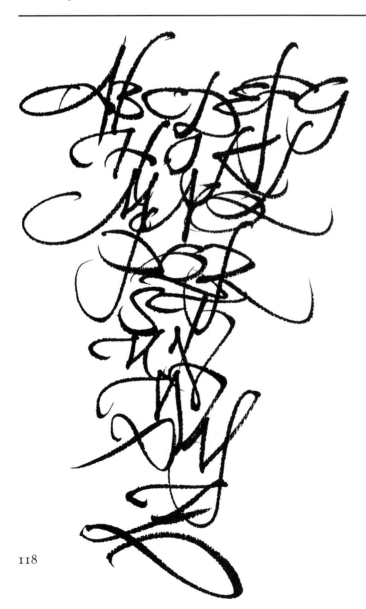

180 Script by Arthur Baker from his book *Calligraphy*, Dover, NY 1973

181 Brush alphabet by Timothy Donaldson

Facing page
182 *Top left:* Experimental calligraphy by John Lancaster
183 *Top right:* Calligraphy by John Lancaster

184 *Bottom:* Landscape drawing with script by John Lancaster

The CHILD likes to make him-self an environment 1990s EDUCATION's task is to facilitate this —

John Lancaster

Grant that all is forgiven

Your home

Rolling hills — fields — & TREES streams gently DEBBIE'S undulate the Cotswolds

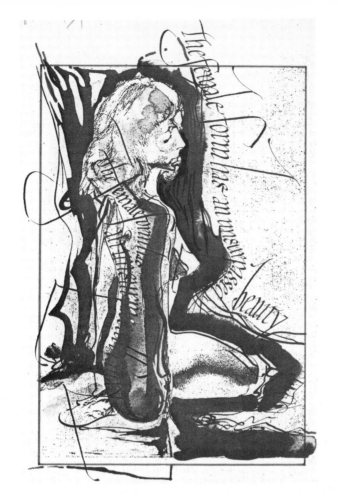

185 Figure and script by John Lancaster

186 A panel of lettering combining both formal and informal hands

187 *Facing page:* Drawing of the figure juxtaposed with script by John Lancaster

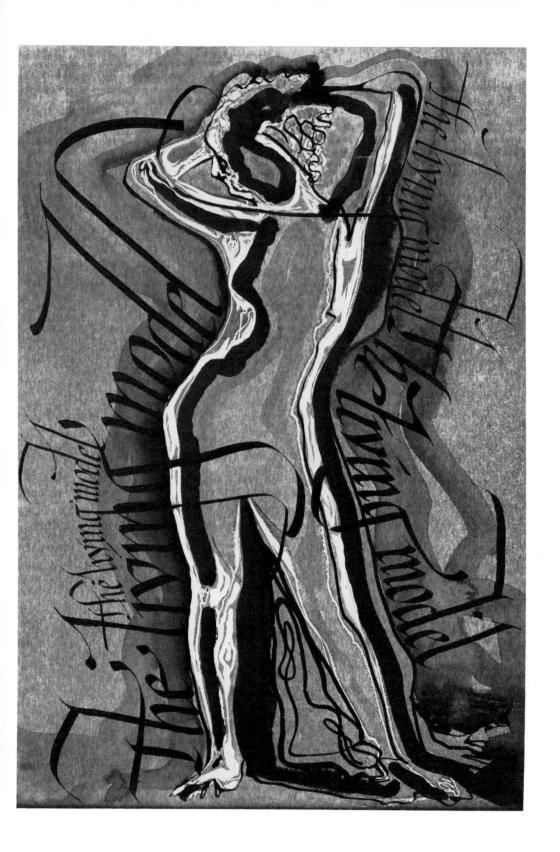

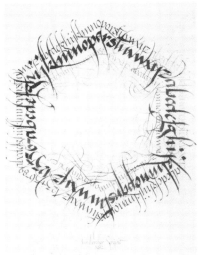

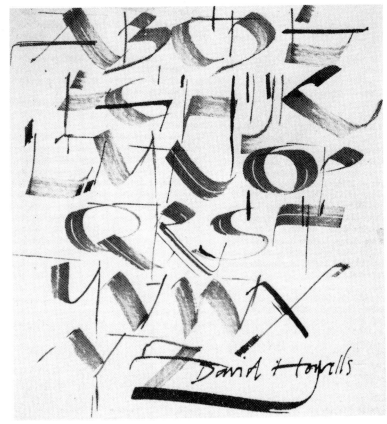

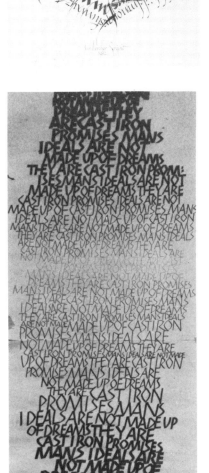

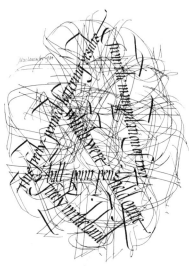

188 *Above left:* A freely rendered script by Jean Larcher

189 *Far left:* Calligraphic panel by Lilly Lee

190 *Above:* Alphabet by David Howells

191 *Left:* Printed and penned script by John Lancaster

192 *Facing page:* Printed and penned script by John Lancaster

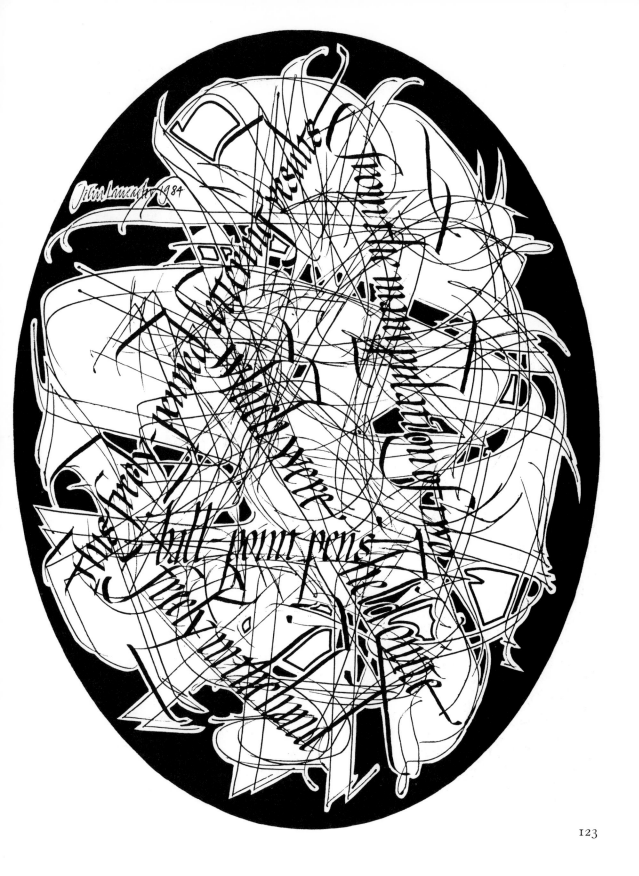

123

A:TREE
BEING
MOTIONLESS
BIRDS
COME
TO:IT:

A Buddha Saying

Aabcc

Alph

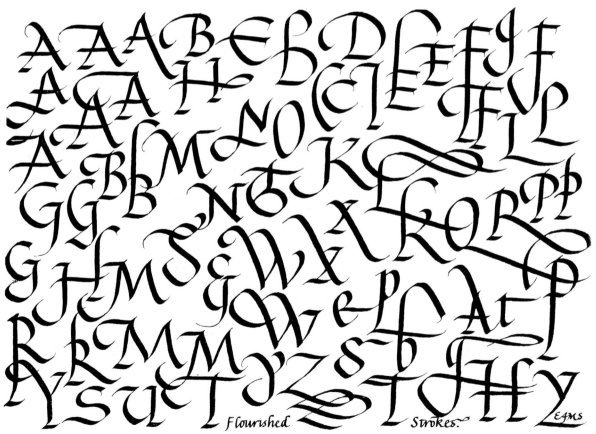

Flourished Strokes. EJMS

124

ghijklmnopqrstuvxyz

et Calligraphy

193 *Facing page, top:* Greetings card designed and executed by John Rowlands-Pritchard

194 *Facing page, bottom:* Alphabet by E John Milton Smith

195 *Above:* A freely rendered piece of calligraphy by Arthur Baker from his book *Calligraphy* Dover, NY, 1973

196 *Right:* Beethoven quote written by Jovica Veljovic

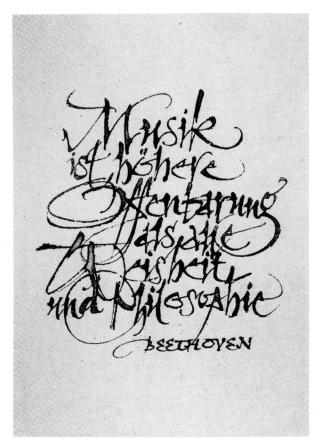

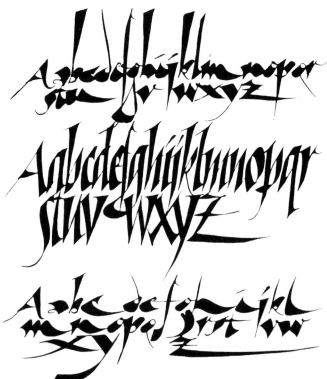

Facing page

197 *Above left:* Freely drawn letters by a fifteenth century scribe. These are interesting but somewhat crudely executed. Fifteenth century British School. MS Bodley 177 fol. 12v. Reproduced by permission of the Bodleian Library, Oxford

198 *Above right:* Three pen manipulated alphabets by Arthur Baker

199 *Bottom left:* Alphabet written by Paul Freeman in sumi red and black ink on museum board with 25 mm brass nib and 25 mm wooden nib. Original size 81 cm × 45 cm

200 *Bottom right:* Illuminated calligraphy by Lilly Lee

201 *Right: Titivillus Calligrapher's Demon.* Special hand developed for this project by Malcolm Drake 1982

Many of the arts and crafts have their patron saint or master but it is only the calligraphers who can claim their very own patron demon. Titivillus is his name.

We all have our personal moments of exasperation when we discover a silly mistake in our writing and we know that feeling of embarrassment when a friend points out some simple mistake in a painstakingly produced piece of writing. How nice it might be to blame the mistake on something or somebody else.

Titivillus was born in the minds of the medieval monks and was used to explain their mistakes. He would creep into the scriptorium unseen and work his evil spells upon the tired and unsuspecting scribe All manner of dirty tricks would be used before he could return to the Devil with his sackful of errors. During the fifteenth century Titivillus diversfied his attentions to the printing houses of Europe. The revival of interest today in calligraphy must mean he is on overtime rates — so please be careful !

9
HISTORICAL CHART

Lettering is the symbolic visual imagery through which human speech is translated. Its history is fascinating and I have attempted to present it in as simple a way as possible in the accompanying chart, in which lettering styles are placed in chronological order.

As basic graphic images, letters articulate language and over the centuries have been used by peoples of various races and cultures as a means of visual communication. Letter forms have changed, depending upon the changing needs of societies and the materials and tools which they used, and this has led to different alphabets having specific characteristics. Quills and reeds produced different images to those of the brush, for instance, and today the felt-tipped pen, typing, printing and computer graphics exert other influences.

In the main, two broad groups classify the development of lettering – *picture writing* (pictograms and ideograms) and *phonography* (full writing). Picture writing developed from man's initial attempts to depict realistic forms and is comprised of symbolic imagery. Phonographic writing, which originated in the Middle East, led eastwards to become pictographic oriental script, and westwards to Egypt, Greece and Rome as a 'classical' form which, though modified, is used world-wide today.

1

EARLY PICTURE WRITING developed about 20,000 BC. This was in the form of PICTOGRAMS or PICTOGRAPHS, which were realistically-based drawings, then as IDEOGRAMS or pictures which represented ideas.

Running

Crying

A horse

2

PHONOGRAPHY or 'full writing' commenced about 4000 BC, and about 2000 BC the Sumerians developed CUNEIFORM LETTERS based upon wedge-like shapes which were often impressed into clay.

3

The Egyptians had three basic types of script around 3000 BC:
HIEROGLYPHICS – generally to be found in the form of picture-writing on temple walls
HIERATIC – which were cursive forms produced by pens and brushes on papyrus
DEMOTIC – or more quickly-written forms of cursive scripts.

A freely rendered example of hieroglyphic characters based upon an eighteenth-century BC Dynasty fresco in Thebes

Hieratic letters produced with a reed pen on papyrus

Demotic letters, again made with a reed pen

131

4

900–700 BC

Between 900 and 700 BC what we refer to as CLASSICAL
LETTERING developed mainly as:
INCISED INSCRIPTIONAL LETTERING

CAPITALS written with quills or reed pens on vellum or papyrus
and known as SQUARE CAPITALS, and RUSTIC LETTERS, which
were written with slanted pens.

Incised capitals used on stone
monuments and tombs

Rustic letters

The quill or reed was cut at this
angle when scribes wrote Rustic
letters

Square capitals

Square capitals resulted from the
square-ended quill or reed

Fragment of papyrus on which is
written some square capitals.
Papyrus 2a, CLA II 118.
Aberdeen University Library

132

5 *Circa* AD 400–900

ROUND HAND – comprised UNCIALS and HALF-UNCIALS. These beautiful scripts were used by Irish and English calligraphers working in the monasteries (*Book of Kells* and *Lindisfarne Gospels*)

Book of Kells. Fol. 200r. Trinity College, Dublin

Angle at which the quill was cut in order to produce this form of script

6

AD 800–1200

CAROLINGIAN MINUSCULE was a beautiful script which Alcuin of York developed at Tours during Charlemagne's great revival of learning. It took half-uncial forms as a model and later developed into *tenth-century* calligraphy associated with the scriptorium at Winchester.

abcde
fghit

moɤ

Calligraphy from tenth-century
illuminated manuscript

abcdeꝼ
ghlmno
ptsuƿ

Square pen and a 30° writing
angle

Ninth-century
Carolingian minuscule

134

7

GOTHIC or BLACK LETTER (a square hand) is angualar in
character because of its lateral compression. It is based on
straight lines, angles and squareness, and requires less space
than round hands. In the late fourteenth and fifteenth centuries
it became highly compressed and difficult to read.

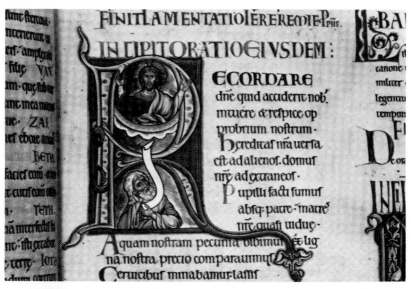

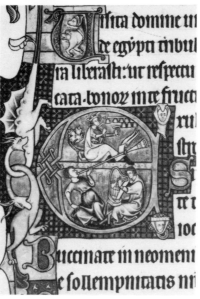

Page from the Winchester Bible.
Twelfth century.
Winchester Cathedral Library.
The Prayer of Jeremiah

Gothic lettering in a fourteenth-
century psalter.
MS Douce 366, fol. 109v Psalm
80. *Reproduced by permission of
the Bodleian Library, Oxford.*

Black letter script from one of
Henry VIII's Plea Rolls (Easter
1541). Public Record Office,
Museum pamphlet 5, Royal
Portraits from *The Plea Rolls*,
1974, KB 27/1119

8

AD 1600–2000

A variety of pen-made scripts such as COPPER PLATE writing, ITALIC handwriting and a range of MODERN PEN HANDS.

Heading for business card. Calligraphy by Sandra Oster, USA

Society of Scribes & Illuminators

Calligraphy by Ienan Rees

Mary Adams Flowers

AN ENGLISH COUNTRY APPROACH TO
FLOWER ARRANGING
WEDDING DESIGN
SILK AND DRIED FLOWERS

4 Kinnerton Place South London SW1·X8EH
01·235·7117

RED ROVER COACH OFFICE,

PIER, ST HELIER'S, JERSEY.

The Red Rover Coach and Omnibus leave the above Office every morning at 9 o'clock and afternoon at 3, for Prince's Tower and Mont Orgueil Castle, Gorey, and leave Gorey for St Helier's, every morning at 11 and afternoon at 5.

A Coach or Omnibus for Pic-nic Parties.

Early nineteenth-century omnibus ticket. John Johnson Ephemera 154. *Reproduced by permission of the Bodleian Library, Oxford*

136

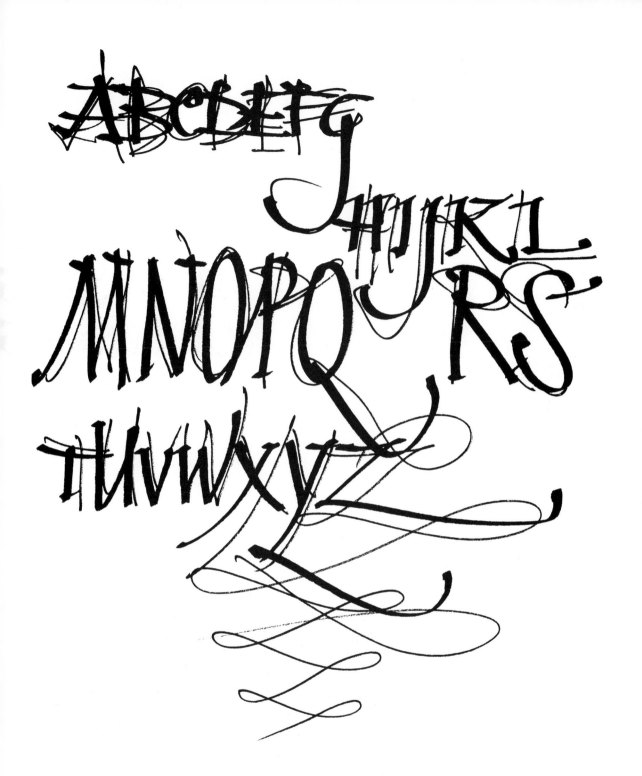

137

BIBLIOGRAPHY

ANDERSON, DONALD M, *The Art of Written Forms: The Theory and Practice of Calligraphy*, Rienhart & Winston, New York 1969

BIGGS, JOHN R, *Letter-Forms and Lettering*, Blandford, Poole 1977

BURGOYNE, P H, *Cursive Handwriting*, Dryad, Leicester 1955

CAMP, ANN, *Pen Lettering*, Dryad, Leicester 1964

CARTNER, WILLIAM C, *The Young Calligrapher*, Kaye & Ward 1969

CHILD, HEATHER, *Calligraphy Today*, Studio Vista 1976

DAY, LEWIS F, *Penmanship of the XVI, XVII and XVIII Centuries*, Batsford 1978

DUMPLETON, JOHN LE, *Handwriting*, Hodder & Stoughton 1980

DOUGLASS, RALPH, *Calligraphic Lettering with Wide Pen and Brush*, Watson Guptill, New York; Pitman, London 1975

EVETTS, L C, *Roman Lettering*, Pitman 1948

FAIRBANK, ALFRED, *A Book of Scripts*, Penguin 1949

FAIRBANK, ALFRED, *A Handwriting Manual*, Faber 1975

FAIRBANK, ALFRED, *The Story of Handwriting: Origins and Development*, Faber 1970

GOURDIE, TOM, *A Guide to Better Handwriting*, Studio Vista 1967

GOURDIE, TOM, *Italic Handwriting*, Studio Vista 1963

GOURDIE, TOM, *Improve Your Handwriting*, Pitman 1978

GOURDIE, TOM, *Calligraphic Styles*, Studio Vista 1979

GOURDIE, TOM, *Handwriting for Today*, Pitman 1971

GOURDIE, TOM, *The Puffin Book of Lettering*, Penguin 1970

GOURDIE, TOM, *The Simple Modern Hand*, Collins 1975

HARVEY, MICHAEL (ed), *Lettering Design*, Bodley Head 1975

HOLME, C G (ed), *Lettering of Today*, Studio Publications, New York; Studio, London 1949

JACKSON, DONALD, *The Story of Writing*, Studio Vista 1981

JOHNSTON, EDWARD, *Writing and Illuminating and Lettering*, Pitman 1977

JOHNSTON, EDWARD, *Formal Penmanship and other Papers* (edited by Heather Child), Lund Humphries 1980

LAMB, C M (ed), *The Calligrapher's Handbook*, Faber 1956

LANCASTER, JOHN, *Lettering Techniques*, Batsford 1982

LARCHER, JEAN, *Calligraphies*, Quinteete, Paris 1984

MARTIN, JUDY, *The Complete Guide to Calligraphy Techniques and Materials*, Phaidon 1984

MAHONEY, DOROTHY, *The Craft of Calligraphy*, Pelham Books 1982

PEACE, DAVID, *Glass Engraving, Lettering and Design*, Batsford 1985

SASSOON, ROSEMARY, *The Practical Guide to Calligraphy*, Thames & Hudson 1984

SWITKIN, ABRAHAM, *Hand Lettering Today*, Harper Row, New York 1976

TAYLOR, MICHAEL, *Contemporary British Lettering*, Skelton Press 1984

THOMSON, GEORGE, L, *New Better Handwriting*, Canongate, Edinburgh 1977

WELLINGTON, Irene, *The Irene Wellington Copy Book* (in four parts), Pitman, 1979

WHALLEY, JOYCE IRENE, *The Student's Guide to Western Calligraphy: an Illustrated Survey*, Shambhala, Boulder & London 1984

WONG, FREDERICK, *The Complete Calligrapher*, Watson-Guptill, New York 1980

ZAPF, HERMANN, *Typographic Variations*, Museum Books, New York 1964

PRINCIPAL CALLIGRAPHY SOCIETIES

Society of Scribes and Illuminators (SSI)

British Crafts Centre
43 Earlham Street
London WC2H 9LD

Society for Italic Handwriting

4 Knifton Court
Mimmshall Road
Potters Bar
London EN6 3DA

Society of Scribes

Box 933
New York
NY 10022, USA

The classic series of William
Mitchell Calligraphy Pens
together with Joseph Gillott
Drawing and Mapping Pens
are distributed by
Rexel Limited
Gatehouse Road, Aylesbury,
Bucks HP19 3DT

Italic

Round
Hand

Script

POSTER

5 line

decro

CopperPlate

Scroll Pens

DRAWING
AND
MAPPING
PENS

Rexel Limited
Gatehouse Road, Aylesbury,
Bucks HP19 3DT

SUPPLIERS

UK

Band, Brent Way, Brentford, Essex *for leathers and vellums*

Berol Ltd, Oldmeadow Road, Kings Lynn, Norfolk PE30 4JR *for all manner of pens, paper and other materials*

William Cowley, Parchment Works, Newport Pagnell, Bucks MK16 0DB *for sheepskin parchment and MSS calfskin vellum*

Faulkiner Fine Papers Ltd, 117b Long Acre, Covent Garden, London *for a very wide range of excellent hand-made and oriental hand-made lettering papers*

Frisk Products Ltd, Unit 4, Franthorne Way, Bellingham Trading Estate, London SE6 *for Supreme Line Surface Paper CS 10*

Local Art Materials Merchants, *for a range of papers, pens, UK inks, etc*

Magros and Philip Poole, 182 Drury Lane, London WC2 *for steel pens and other writing materials*

Osmiroid, Gosport, Hampshire *for Calligraphic paper 17993, pens and other calligraphic materials*

Paper Chase, Tottenham Court Road, London *for a wide range of hand-made and other papers and card*

Pentographics, Ltd, March Road, Lords Meadow Industrial Estate, Crediton, Devon EX17 1EU *for Dart table-top easel complete with 60cm × 45cm board*

Platignum Pen Co, Mentmore Manufacturing, Platignum House, Six Hills Way, Stevenage, Herts *for a range of fibre and felt-tipped pens, fountain pens and sets*

Philip Poole, 182 Drury Lane, London WC2 *for a selection of pens, brushes and calligraphic inks*

Rexel Ltd, Gatehouse Road, Aylesbury, Bucks HP19 3DT *for 'Wm Mitchell' calligraphy pens and 'Joseph Gillott' pens*

Winsor and Newton Ltd, 51 Rathbone Place, London W1 *for pens, inks, papers, card, drawing boards, easels and other materials*

WEST GERMANY

Rotring Company, Hamburg, West Germany *for Rotring Art Pens available in three sizes*

USA

Art Media, 8205, W 10th Ave, Portland, Oregon 97205 *for calligraphic materials*

Pentalic Corp, 132 W 22nd Street, New York, NY 10011 *for inks and pens*

Koh-I-Noor, 100 N Street, Bloomsbury, New Jersey, USA *for Rotring Art Pens available in three sizes*

INDEX

ADSO OF MELK 84–5
Alphabet 27, 39, 43, 48–9, 50, 52, 56, 60, 63, 66, 69, 79, 108, 112, 114, 118, 122, 125, 128
Angle(s) 32, 37–8, 55, 62
Art 9, 14, 52, 84, 106
Art form 82
Artist 31, 84, 86
Artistic 84, 96
Artistry 9, 82
Art/design 25
Ascender(s) 36, 62–3

BAKER, ARTHUR 118, 125
Ball-point 12, 14, 17, 27, 31–2, 35, 43, 52, 62, 79
BARRIE, STUART 76
Basic strokes 38
Bench 28
Berol pens 12, 62, 112
Board 11, 22, 28
Book art 82
Book(s) 52, 62, 82, 84, 86–8, 107
Boxall pens 12
Broadside(s) 90–1, 94
BROCKLEHURST, ERIC 102
Brushes 11–12, 19–20

Calligraphy 14, 28, 34, 36, 50, 52, 57, 61–2, 73, 82, 92, 96, 106, 118, 127, 134, 136
Calligrapher(s) 9, 11, 13–14, 18, 25, 28–9, 31, 38–9, 50, 52, 62, 84, 92–3, 106, 133
Calligraphic kit 11
Calligraphic forms and images 14, 16–18, 21, 23, 122
Capital(s) 36, 40, 60, 79
Card 27–9, 58, 73, 106
Carolingian 40, 134
Centering 91–2, 94
CHILD, HEATHER 40
Circle(s) 9, 50, 52, 106, 117

Coit pens 12
Copyist(s) 85
Craft 11, 14, 18, 43, 48, 82, 106
Craftsman(men) 31, 91
Craftsmanship 84
Creativity 9
Cuneiform letters 130

Dart table easel 28
Decorative arts 22
Decorative capitals 52, 54
Decorative lettering 62, 64
Descender(s) 36, 62–3
Design(s) 9, 52, 82, 91–3, 102, 112
Designing 9
Desk(s) 11, 18, 21, 85–6
DRAKE, MALCOLM 61, 127
Drawing 14, 16, 20
DONALDSON, TIMOTHY 69, 118

Easel 11, 22, 24–5
Edding pens 12, 34, 36, 52, 112
Entablature 23, 43
Eraser(s) 11
Experiment(tal) 21, 50, 106, 117

Feather(s) 12–13
Felt-tipped 12, 14, 16–18, 20, 23, 27, 35, 55, 128
Fibre-tipped 12, 36, 52, 62, 76, 106, 112, 117
Folio(s) 85
Form(s) 16, 20, 39
Formal 29, 36, 40, 46, 52, 58, 62, 74, 79, 87, 91, 120
Foundation hand 38, 79
FREEMAN, PAUL 127

GARDNER, W M 92
Gilding (gold) 84, 90–1
Goose 12
Gothic 64, 135
Gothicised 79

Graphic 14, 23, 128
Graphicacy 9, 20, 82
Guide lines 46

Handwriting 62
HECHLE, ANN 25, 66, 69, 74, 79, 98
Heintz & Blanckert pens 12
Hieratic 131
Hieroglyphics 131
HOWELLS, DAVID 70, 72, 77, 122

Ideogram(s) 129
Iluminating 21, 82, 84–5
Illuminated address(es) 90–1
Illuminator(s) 9, 82, 85, 114
Image(s) 9, 14, 17–18, 20–1, 23, 29, 106, 128
Imagery 14, 17–18, 117, 128
Image-making 21
Implement(s) 35
Informal 62, 120
Ink(s) 11, 18, 26, 29, 36, 40, 43, 69, 79, 84–5, 91, 94, 112, 127
Inkhorns 85
Instrument 29, 62
Inventiveness 106, 117
Italic 12, 62–6, 69, 76, 79, 92, 114, 136

JOHNSTON, EDWARD 9, 36, 38, 40, 92
John Calhoun State Community College 29

Kit 11

LANCASTER, JOHN 17, 43, 54, 58–60, 66, 69–71, 73, 90–1, 94, 98, 102, 117–8, 120, 122
LARCHER, JEAN 52, 56, 66, 100, 122
Layout 9, 82, 93
LEE, LILLY 61, 72, 127
Letter(s) 18, 27, 31, 36–40, 43, 48,

50, 52, 58, 62–4, 79, 84, 92, 96, 127, 130, 135
Letter forms 18, 26, 28, 39, 64–5, 93, 128
Letter-heights 37
Letter-patterns 22
Lettering 9, 14, 23, 66, 69, 74, 76, 82, 96, 106–7, 117, 120, 128, 132
Line(s) 18, 20, 32, 34
Lombardic 64
Lord Chamberlain 50
Lower-case 36, 40
Loyal address(es) 50

Majuscule(s) 36, 39–40, 43, 49–50, 52, 58, 63–4
Manipulative skill(s) 9
Manuscript(s) 9, 26, 52, 82, 84, 86–8, 134
Margin(s) 88, 91, 94, 102
Mark making 14, 18
Materials 9, 11, 18, 28, 106, 112, 128
Medieval 18, 21–2, 82, 84, 87
Metal nib 22
Middle Ages 21
MILTON-SMITH E JOHN 9, 38, 43–5, 63, 66, 90, 125
Minuscule(s) 36, 39–40, 43–4, 50, 52, 63
Mitchell William pens 12, 22, 62
Monastery 21, 43, 133
Monk(s) 22, 26, 43, 84–6

Nib(s) 11–12, 22, 36, 38, 62, 112, 117, 127

O'SULLIVAN, LIZ 73
OSTER, MARY 136

Page(s) 84, 86–8
Page openings 86, 88
Painting 9
Paper 12, 18, 28–9, 31–2, 43, 46, 69, 87, 91, 106, 108
Parchment(s) 22, 84–5
Pattern(s) 31–2, 34–6
Pen(s) 9, 11–14, 17–23, 25, 27–9, 31–2, 34–8, 40, 43–4, 48, 52, 55, 58, 62, 76, 79, 86, 91, 106, 112, 128, 131–2, 134
Pencil(s) 12, 14, 27, 31–2, 35, 66, 112

Penknife 12–13
Penholder(s) 12
Penmanship 9, 14, 26, 36, 40, 72
Pen strokes 32, 38
Pen width(s) 36, 40, 46
Phonography 128, 130
Picture writing 128–131
Pigment(s) 11, 18, 20
Planning 82, 86
Plastic arts 9
Poetry 92, 94
POOLE, JOHN 66, 70, 96
Primary feather(s) 12
Psalter(s) 84–5

Quarto 87–8
Quill(s) 11–14, 18, 21–2, 24, 26, 29, 40, 43, 52, 73, 84–5, 106–7, 112, 128, 133
Quire(s) 87

Reed pen 106, 128
REES, IENAN 58, 136
Reservoir(s) 12, 22
Rhythm 31–2
Rhythmic 35
Rhythmical 35, 38
RIDLINGTON, E M 88
Roman lettering 23, 40, 79
Round hand(s) 9, 29, 36, 40, 43, 52, 63, 133
ROWLANDS-PRITCHARD, JOHN 125
Rubricator(s) 84–6
Ruler 12, 85
Rustic script(s) 87, 132

SAMPSON, AYLWIN 76, 88
Scalpel 12
SCHOFIELD, DEREK 98
Scribe(s) 9, 11, 13, 18, 21–2, 24, 26, 38, 43, 82, 84–7, 92, 114, 127
Script(s) 13, 21, 25, 27, 29, 36, 40, 43, 46, 50, 52, 60, 62, 84, 87, 91, 106, 117–8, 120, 122, 131, 133–6
Scriptorium (scriptoria) 21–2, 26, 36, 82, 84–6
Scroll(s) 62, 90–1
Semi-formal 60
Serif(s) 37–8, 40, 52, 55, 63
Sheepskin 94
Skill(s) 9, 18, 31, 35, 84, 106
Spacing 64
Square capitals 86, 132

Square-ended pen 9, 27, 35, 43, 62, 69
Starting points 18, 106
Stick ink 11, 16
Structural sheet(s) 44, 47, 49
Studio(s) 23, 82, 84
Style(s) 9, 21, 84, 87, 128
Stylus 86, 106
Surface(s) 18, 25–9
Swan 12
Swash letters 64
SWINDLEHURST, THOMAS 40, 100, 103

Table 11, 18, 28
Technique(s) 9, 18, 21, 36, 106
Tempera 90
Tenth century 9, 36, 40, 48, 50, 52, 61, 134
Text 62
Trajan 40
Turkey 12

Uniconium 23, 43

VELJOVIC, JOVICA 125
Vellum 12, 18, 22, 28, 79, 84, 86–7, 90–1, 106–7, 132
Versal(s) 79
Visual arts 9
Visual communication 26

WATER, SHEILA 79
Wax tablets 86, 106
Winchester 21, 36, 38, 40, 50, 134–5
WOODCOCK, JOHN 96
Work(s) of art 26, 84
Work bench 28
Work top 28
Working surface(s) 18, 20, 27–8, 36
Workshop 21, 26, 82, 85
Workshop Wales 74
Writer 31
Writing 9, 14, 21–2, 24, 26–8, 31, 38, 40, 43, 48, 52, 66, 69–70, 84–8, 94, 100, 131, 136
Writing angle 11, 28
Writing hand 9, 21
Writing line 36, 50, 62
Writing position 28
Writing studio 21
Written word 26
Wroxeter 23, 43